IMAGES
of America

SWEDISH SEATTLE

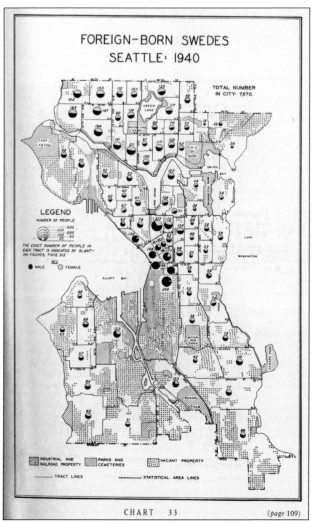

FOREIGN-BORN SWEDES
SEATTLE: 1940

TOTAL NUMBER
IN CITY: 7,670.

LEGEND
NUMBER OF PEOPLE
300-500
100-600
-50
THE EXACT NUMBER OF PEOPLE IN
EACH TRACT IS INDICATED BY SLANT-
ING FIGURES, THUS 313.
SEX
● MALE ○ FEMALE

INDUSTRIAL AND
RAILROAD PROPERTY PARKS AND
CEMETERIES VACANT PROPERTY
—— TRACT LINES ——— STATISTICAL AREA LINES

CHART 33 (page 109)

The 1944 study *Social Trends in Seattle* by Calvin F. Schmid, professor of sociology at the University of Washington, contains a wealth of data about the residents of Seattle in 1940. The census that year showed a foreign-born population of 63,470 in a total population of 368,302. Swedes represented the third-largest group at 7,670 (12.1 percent), just behind the Norwegians at 8,436 (13.3 percent). The number of Swedish immigrants in Seattle climbed steadily from 1890 to 1920, reaching a plateau in that decade before beginning a gradual decline after 1930. This chart shows that Swedish immigrants lived in all parts of Seattle, not just Ballard, although that neighborhood accounted for 11.7 percent of the total. The adjacent neighborhoods of Fremont and Wallingford accounted for another 9.4 percent of Swedish-born Seattle residents in the 1940 census. (Courtesy University of Washington Press.)

ON THE COVER: The Svea Male Chorus and guests enjoy a picnic at Fortuna Park, a popular destination for summer outings on Mercer Island, in 1909. The Svea Male Chorus, hosts of the Union of Swedish Singers of the Pacific Coast Convention held during the Alaska-Yukon-Pacific Exposition (AYPE), invited Madame Hellström Oscar and Mr. Oscar from the Royal Opera in Stockholm to be guest soloists at the Swedish Day concert. (Courtesy Claude Nelson and Svea Male Chorus.)

IMAGES
of America

SWEDISH SEATTLE

Paul Norlen

ARCADIA
PUBLISHING

Published by Arcadia Publishing
Charleston SC, Chicago IL, Portsmouth NH, San Francisco CA

Printed in the United States of America

Library of Congress Catalog Card Number: 2007927174

For all general information contact Arcadia Publishing at:
Telephone 843-853-2070
Fax 843-853-0044
E-mail sales@arcadiapublishing.com
For customer service and orders:
Toll-Free 1-888-313-2665

Visit us on the Internet at www.arcadiapublishing.com

*In memory of my father, Carl Martin Norlen (1919–1978),
a great Swedish American*

"Snoose Junction" was a common nickname for neighborhoods where Swedes lived or gathered; "snoose" (Swedish *snus*) refers to the form of tobacco preferred by many Swedish immigrants (and contemporary residents of Sweden as well). At some point, ethnic Americans began to celebrate their heritage with buttons and refrigerator magnets. (Courtesy Dave Wolter.)

CONTENTS

ACKNOWLEDGMENTS

This project would not have been possible without the generous, enthusiastic support of a number of organizations and individuals.

—Nordic Heritage Museum, with particular thanks to director Marianne Forssblad and curator Lisa Hill-Festa

—Frihet Lodge, Order of Vasa

—Museum of History and Industry, in particular Carolyn Marr

—North Star Lodge No. 2

—*Seattle Post-Intelligencer* and publisher Roger Oglesby

—Shoreline Historical Museum and Vicki Stiles, director

—Svea Male Chorus

—Swedish Cultural Center

—Swedish Finn Historical Society

—Swedish Women's Chorus

—University of Washington Libraries, Special Collections, especially visual materials curator Nicolette Bromberg.

—Clinton White—a cornucopia of anything relating to Seattle

I am also grateful to the following individuals for their assistance: the late Thomas Alberg and his daughter Katie Alberg; Don Meyers; Kathi Ploeger; Janet Park; Jules James; Christy Wicklander; Rod Zakrison; Elov Bodin; Syrene Forsman and her late husband, Don Forsman; Bill Engstrom; Irwin Nash; John Pursell; Claude Nelson; Randy Nelson; Gail Stevens; Ken Lee; Steven Hanson; Cathy Pratt; Alana Granstrom; Lilly Moen; Kathy Anderson; Charlie and Lura Belle Anderson; Beverley Sperry; Dave Wolter; Solveig and Astor Rask; Tina Swenson; Carolyn Purser; Carolee Jones; Marianne Hanson; Evelyn Edens, *Seattle Times* photography department; Lytton Smith, *Seattle Post-Intelligencer* photography department; Don Ostrand; Lillian Brubaker; Julie Albright; R. W. Clay; Brian B. Magnusson; Jay Wallain; Rev. P. Kempton Segerhammar; and Gunnar Wallin.

INTRODUCTION

This book is an attempt to suggest the range of activities associated with Swedish immigrants and their descendants in Seattle. What things are Swedish about Seattle? Some of the organizations established by immigrants, such as churches, fraternal lodges, and temperance societies, had their origins in their home country. Other institutions, such as the Swedish Club, were formed from a desire to socialize with fellow immigrants. Other, more personal pastimes—taking any opportunity to drink coffee outdoors, for example, or serving *lutfisk* and other traditional foods at Christmas—have their roots in rural, Swedish culture.

Swedish immigrants were not among the first to arrive in the new city of Seattle. Early arrivals from Sweden to the Pacific Northwest tended to gravitate to Tacoma or to the forests and farmlands of the region. Lutheran minister Peter Carlson visited Seattle in 1879 and commented that there were few Swedish residents at that time. But by 1885, there were at least a few hundred Swedes living in Seattle, whose population had increased by then to about 5,000. It was around this time that the first Swedish church congregations—Lutheran, Baptist, Methodist, and Mission Covenant—were organized in the city.

A larger influx of immigrants, from Sweden and elsewhere, began after the Great Fire of 1889. In the wake of the Klondike gold rush of 1897, with its attendant business opportunities, even more Swedish immigrants made their way to Seattle, often after time spent in the East and Midwest, Alaska, or Canada. The number of Swedish immigrants calling Seattle home continued to climb, reaching its highest point in the decade from 1920 to 1930. After that, the number of "foreign-born" Swedes in the city began a steady decline.

Where could Swedish Seattle be found? Many of the early Swedish residents of Seattle congregated in an area centered roughly around Howell and Stewart Streets between Eighth and Ninth Avenues. The Swedish Club, for example, was on the corner of Eighth Avenue and Olive Way, while Gethsemane Lutheran Church moved after a few years from its original location in the downtown core to Ninth and Stewart Streets. Swedish businesses, such as the Scandia Café, were in the neighborhood as well. But Swedes also lived throughout the city, with sizeable numbers in Ballard, Fremont, Wallingford, West Seattle, and Youngstown.

For the most part, Swedish Seattle looked much like the rest of the city. While there was a public face to the Swedish American community—Swedish Hospital, for example—the Seattle Swedish experience was more often an essentially private one, played out in homes, lodges, and churches among fellow immigrants.

What did Swedish Seattle sound like? In the early days, Swedish was the language of church services and lodge meetings. The Swedish language, in various dialects, was heard wherever Swedes encountered each other. Outside the Swedish community, however, learning English was a necessity, and Swedish immigrants were almost always quick to adopt the new language. Even after English started to predominate, conversations might still have been sprinkled with Swedish words and, in the case of many immigrants, was marked by a strong Swedish intonation. (Local entertainers such as Doug Setterberg and Stan Boreson exploited this phenomenon to comic effect in the 1950s and 1960s for an audience that could still appreciate the dual-language humor.)

Swedish gatherings of any sort often involved singing, perhaps by one of the city's many Swedish choral groups, both male and female. Today Swedish songs are most often sung in connection with Lucia Day (December 13), the Christmas season, and Midsummer celebrations. Well into the 1940s, the sound of Swedish dance music, featuring fiddles and accordions, was regularly heard at the Swedish Club and other places, perhaps played by a popular dance band such as Bert Lindgren's Orchestra.

Where might Swedish Seattle be found today? Many descendants of Swedish immigrants still live in the Seattle area, although their surnames may be the only outward indication of their Swedish heritage. Immigrants from Sweden continue to arrive, although certainly not in the large numbers of earlier waves of Scandinavian newcomers, some to become permanent residents and others to work for a few years (perhaps at a local software company or in other high-tech industries) before returning to Sweden. A number of local organizations have a Swedish profile, including the Swedish Cultural Center (as the Swedish Club is now called), Swedish Cultural Society (*Kulturförbundet*, founded in 1921), SWEA (Swedish Women's Educational Association), and several Vasa lodges. Organizations such as the Nordic Heritage Museum and Swedish-Finn Historical Society have been founded to document and preserve the immigrant experience. The Skandia Folkdance Society, whose members are not necessarily of Scandinavian descent, has promoted Scandinavian folk dance and music traditions since 1949 through dances and workshops. The University of Washington Department of Scandinavian Studies offers courses in Swedish language and related subjects, as well as a graduate program. Sweden has maintained a consulate in Seattle for many years, and the Swedish American Chamber of Commerce promotes Swedish and Swedish American business interests in the Puget Sound area.

In the early 21st century, the Swedish language seems to have an exotic appeal (especially its three unique letters), as seen in names for local condominiums and hotels such as Hjärta (heart) and Ändra (to change). And for many Seattle-area residents, the most obvious local Swedish landmark is furniture retailer IKEA, the place to go for that traditional Swedish staple, meatballs.

Swedish Seattle is a representative overview, not a comprehensive history, of what was once one of the city's largest ethnic groups. A different author, and a different selection of pictures, might tell a slightly different story, but the general outlines would be more or less the same. Each of the numerous organizations, lodges, and churches mentioned in this book has its own story, as do the thousands of Swedish immigrants and their descendants who have made Seattle their home. Those stories should be told, if only for their own descendants. If you have photographs, letters, or artifacts that may be of historical interest, consider donating them to a local archive, such as the Nordic Heritage Museum. Future, more detailed histories of the Swedish American community will depend on it.

Please enjoy this excursion through more than a century of *Swedish Seattle*.

One

MAKING A START

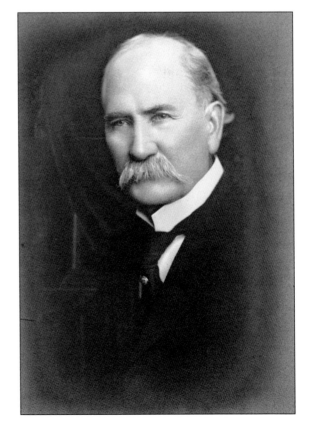

Andrew Chilberg, shown in a studio portrait in 1897, became one of the most prominent businessmen in the Swedish community and the city of Seattle. Chilberg was born in Sweden in 1845, but emigrated at the age of one with his parents, who settled first in Iowa. Chilberg's brother Nelson arrived in Seattle in 1872. Andrew joined him three years later, opening a grocery store, the first Scandinavian business in Seattle. The success of Chilberg Brothers led to a number of other business ventures. (Courtesy Nordic Heritage Museum.)

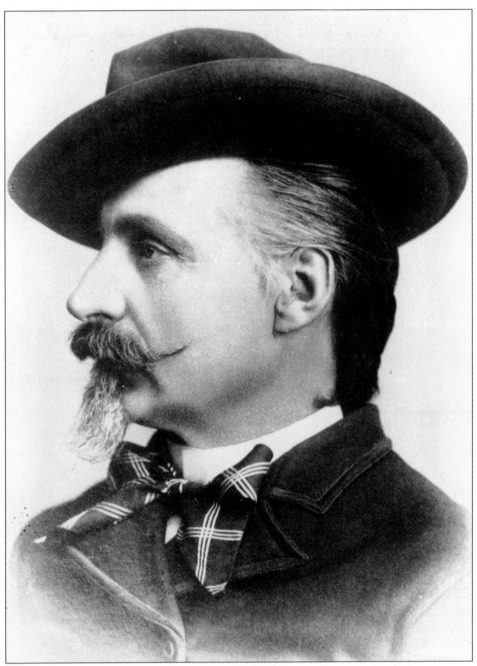

Count Johan Gustaf Kalling (1842–1919) was one of the more unusual, early Swedish immigrants to the Pacific Northwest. Kalling arrived in the United States in 1865, and spent time in Minnesota, California, and Oregon before arriving in Washington, where he was a Seattle resident for a number of years from the late 1870s until 1900, when he returned to his native Sweden. A self-taught painter, Kalling brought many pieces back to Sweden with him, including views of Snoqualmie Falls and Mount Baker, which are still in the possession of the count's family. A large-scale piece, *View of Port Angeles*, can be seen in the Clallam County Museum. This portrait was taken at Landbraas Studio, 614 Front Street (now First Avenue) in Seattle. (Courtesy Carl Kalling.)

Among the early Swedish residents of Seattle were Mr. and Mrs. Lindquist. This portrait was taken at the Eggan Studio at 207 Pike Street around 1890. The Norwegian-born James Eggan opened his photography studio in Seattle in 1889 at age 17. (Courtesy Nordic Heritage Museum.)

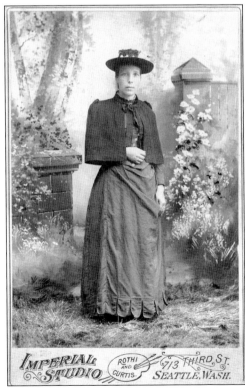

A few years later, Anna Lindquist had her portrait taken at the Imperial Studio, located at 713 Third Avenue. (Courtesy Nordic Heritage Museum.)

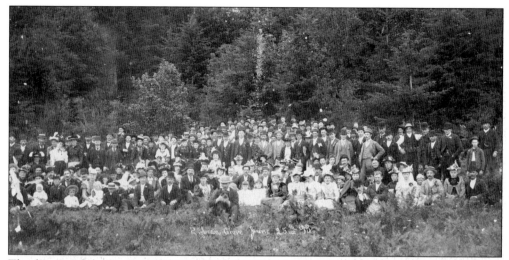

The first Swedish organization to be formed in Seattle that was not a church was the Swedish Club. In 1892, a group of young Swedish men, most of whom were living in the Stockholm Hotel on First Avenue, decided to form a Swedish Club. The hotel, owned by Andrew Chilberg, also housed a restaurant and the offices of the newspaper *Svenska Press* (the *Swedish Press*). The new organization held its first *Midsommar* celebration, pictured, the following June at a place called Sylvan Grove on the east side of Lake Union, just a streetcar ride away from downtown Seattle. (Courtesy Nordic Heritage Museum.)

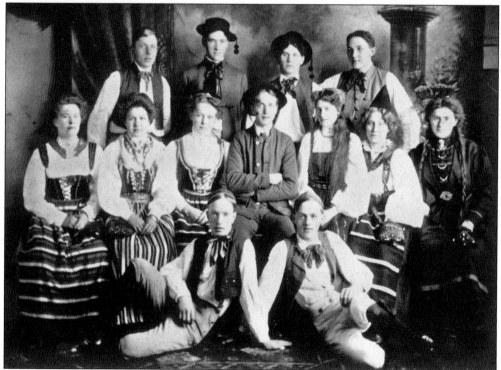

The Swedish Club soon became the center of social activities in the Swedish community. The club's dance team kept Swedish folk dance traditions alive in the new land and also entertained at many club functions. (Courtesy author's collection.)

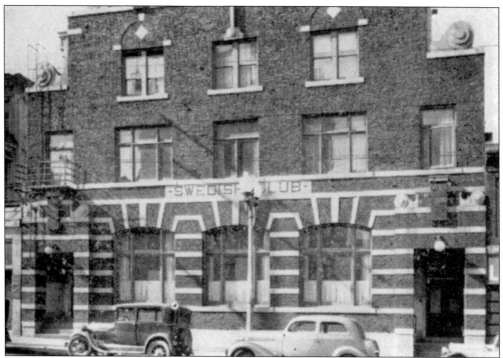

At first, the Swedish Club held its meetings and events in rented facilities. In 1902, the Swedish Club erected its own building at a lot on the corner of Eighth Avenue and Olive Way, purchased by N. B. Nelson and resold to the club on favorable terms. (The first group to rent space in the new building was North Star Lodge No. 2 of the International Order of Good Templars.) In 1909, the Swedish Club was substantially renovated, and the building remained a hub of activity for the Swedish community, as well as many unions and lodges, until the new Swedish Club was completed on Dexter Avenue North in 1961. (Courtesy author's collection.)

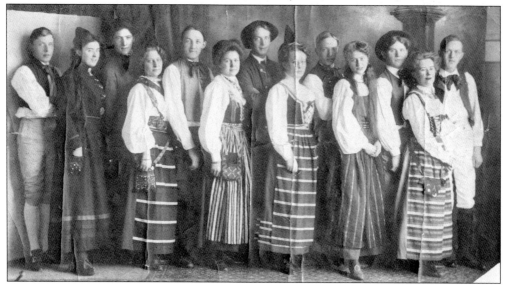

The *nationaldanslag* (national dance group) at the Swedish Club was organized in 1907. (Courtesy Nordic Heritage Museum.)

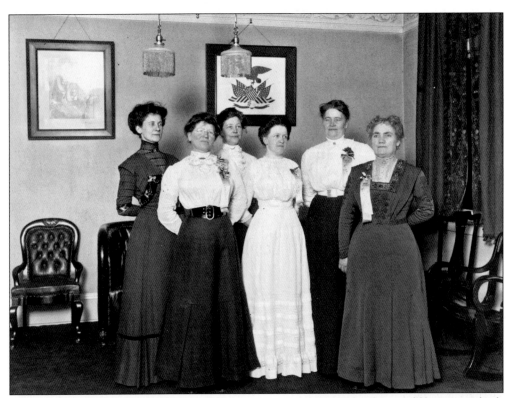

When the Swedish Club was formed in 1892, it was decided that membership would be open to both men and women. A week later, however, a new vote reversed that decision, and the club did not admit women as members until 1989. However, in 1905, the Freija auxiliary was formed as a sister organization to the club. These members of Freija are shown inside the Swedish Club in the 1910s. (Courtesy *Seattle Post-Intelligencer* Collection, Museum of History and Industry [MOHAI].)

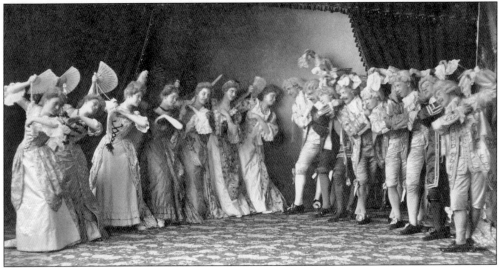

The activities of the Swedish Club were open to both men and women. Masquerade and costume parties were a perennial favorite, such as this Colonial Ball held in 1903. (Courtesy University of Washington [UW] Special Collections, UW26886z.)

14

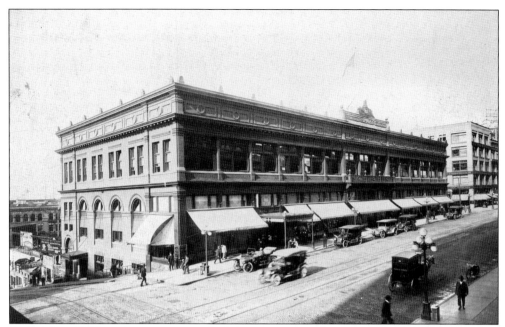

Frederick and Nelson furniture store, which later grew into a large downtown department store, was located at 208–210 Pike Street in 1892, when this picture was taken. Nels B. Nelson was a Swedish immigrant who arrived in Seattle in 1890. He quickly established himself as a successful businessman and was a popular and active member of the Swedish community. (Courtesy Nordic Heritage Museum.)

A sure sign of acceptance in the Seattle business establishment was to be included in one of the caricatures printed in the *Argus* depicting prominent Seattle business and political leaders. Many of these caricatures were collected in the book *Men Behind the Seattle Spirit: The Argus Cartoons* in 1906. Apparently Nels Nelson had a reputation as an enthusiastic bowler. (Courtesy Clinton White.)

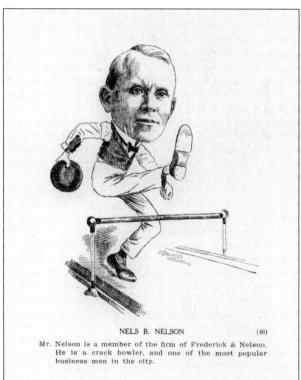

NELS B. NELSON (46)

Mr. Nelson is a member of the firm of Frederick & Nelson. He is a crack bowler, and one of the most popular business men in the city.

15

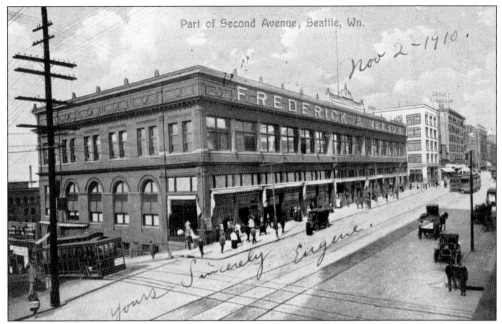

Frederick and Nelson department store at its Second Avenue location is depicted on a postcard from 1910. The store, which later moved to larger quarters at Fifth Avenue and Pine Street until it was closed in 1992, is still fondly remembered by many Seattle residents. (Courtesy Clinton White.)

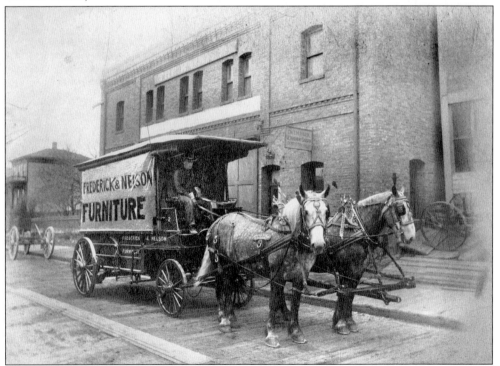

In the early days, deliveries from the Frederick and Nelson furniture store might be made in a horse-drawn wagon. (Courtesy Nordic Heritage Museum.)

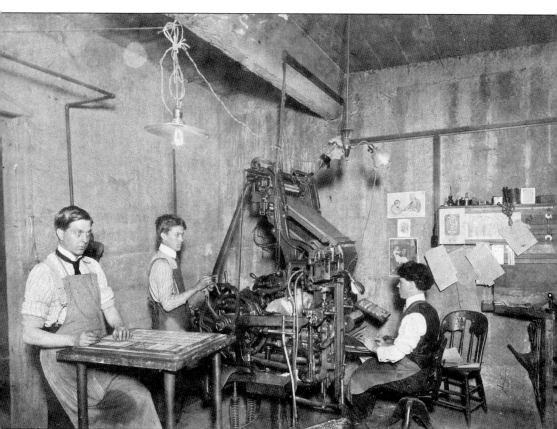

By the start of the 20th century, Seattle boasted several Swedish-language newspapers. Linotype operator Peter Adamson, right, is hard at work here on the next edition of *Svenska Pacific Tribunen* (*Swedish Pacific Tribune*) assisted by Andrew Odegaard (left) and Martin Anderson in February 1904. (Courtesy UW Special Collections, UW5788.)

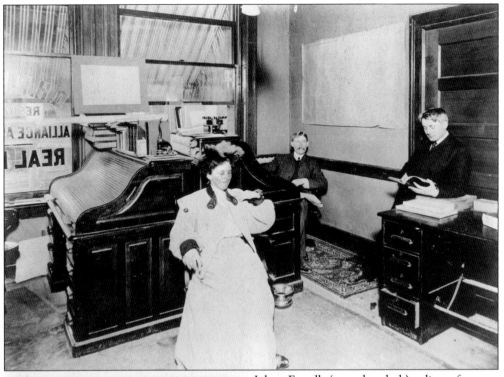

Johan Egardh (seated at desk), editor of the *Svenska Pacific Tribunen*, is seen in the newspaper's offices in 1905. The newspaper office was on the second floor of the Times Building at Second Avenue and Union Street, while production was in the basement of the John Erikson Building on First Avenue. (Courtesy author's collection.)

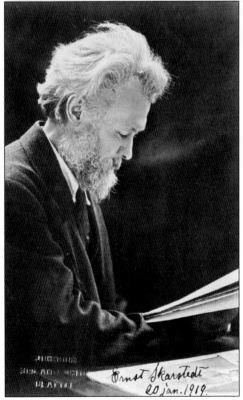

The writings of Swedish-born journalist Ernst Skarstedt (shown in 1919 at age 60) are an important source of detailed information about the first half century of Swedish settlement in the state of Washington. A key publication is *Washington och dess svenska befolkningen* (*Washington and Its Swedish Population*) from 1908. (Courtesy author's collection.)

Gethsemane Lutheran Church was organized in February 1885 by Augustana Synod pastor and missionary Peter Carlson with 26 founding members. Originally located on Third Avenue near Pike Street, the church moved to its present location at Ninth Avenue and Stewart Street in 1901. Other Lutheran churches with Swedish connections eventually grew out of this downtown "mother church." (Courtesy UW Special Collections, A. Curtis 590.)

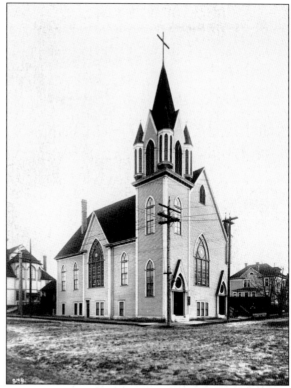

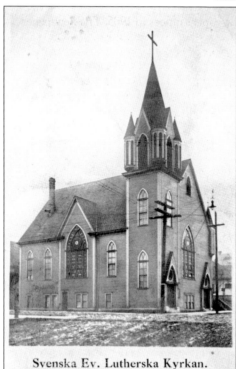

Svenska Ev. Lutherska Kyrkan.
Seattle, Washington.

This postcard shows Gethsemane Lutheran Church, also known as the "Swedish Evangelical Lutheran Church." (Courtesy Nordic Heritage Museum.)

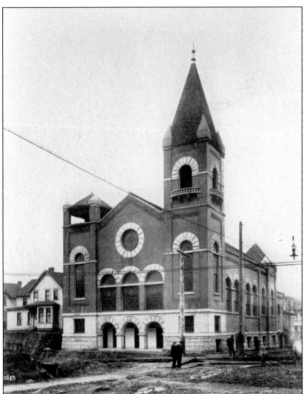

First Swedish Baptist Church, founded in 1889 and originally located at Fifth Avenue and Olive Way in downtown Seattle, moved to the corner of Ninth Avenue and Pine Street in 1904. The photograph of their new church building was taken in 1909. (Courtesy Nordic Heritage Museum.)

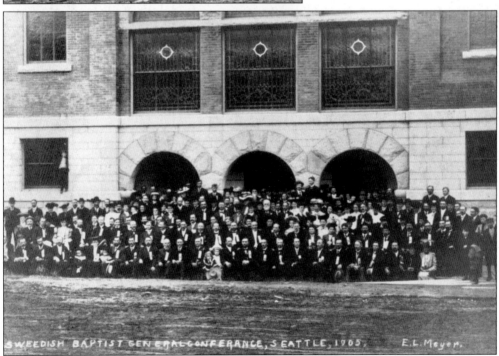

The Swedish Baptists held their general conference in Seattle in 1905 and are shown outside the church building. (Courtesy Nordic Heritage Museum.)

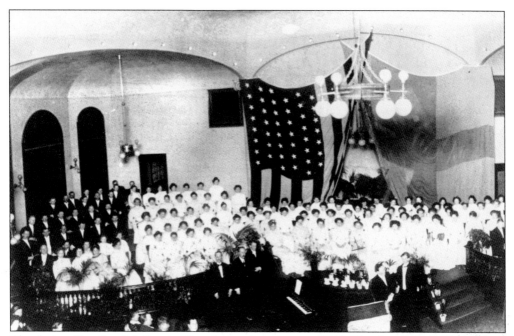

The choir at First Swedish Baptist Church sings for services in 1912. The church, long an important part of the Seattle Swedish community, was later renamed Central Baptist. (Courtesy Nordic Heritage Museum.)

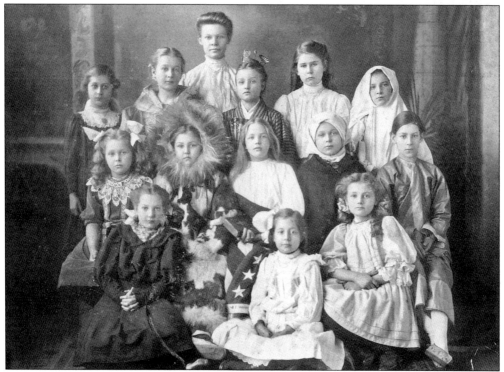

This Sunday school class at First Swedish Baptist Church seems to be preparing for a performance of some kind in 1910. (Courtesy Nordic Heritage Museum.)

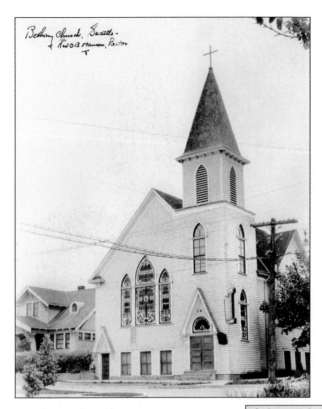

Bethany Lutheran Church, an offshoot of Gethsemane Lutheran, the "mother church" in downtown Seattle, was organized in January 1908. Located in Ballard, it later joined in the formation of Our Redeemer's Lutheran in 1944. (Courtesy author's collection.)

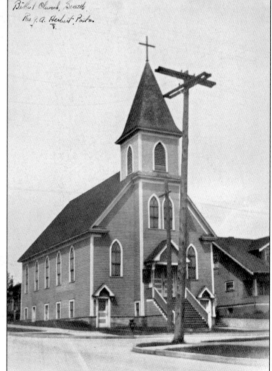

Another Seattle church whose membership was mainly drawn from the Swedish and Swedish-Finnish communities was Bethel Church, located on Twenty-second Avenue NW in Ballard. (Courtesy UW Special Collections, UW26889z.)

The Seattle congregation of the Swedish Methodist Church (also known as the Swedish Methodist-Episcopalian Church) was organized in 1883. The following year a lot was purchased at Fifth Avenue and Pike Street for a church building. In 1905, the church relocated to the northeast corner of Pine Street and Boren Avenue. This view is from 1909. (Courtesy author's collection.)

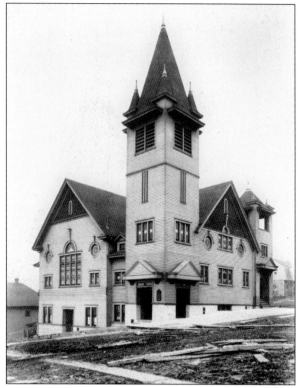

Pictured here is a later view of the First Swedish M.E. Church. The building was erected in 1905. (Courtesy Nordic Heritage Museum.)

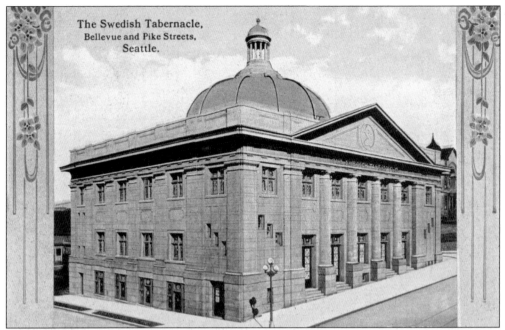

The Swedish Tabernacle, Bellevue and Pike Streets, Seattle.

The Mission Covenant Church constructed an imposing structure in 1910 at Bellevue Avenue and Pike Street in Seattle, known as the Swedish Tabernacle. The building is still the home of the First Covenant Church, which maintains its Swedish heritage through an annual Lucia celebration during the Christmas season. (Courtesy Clinton White.)

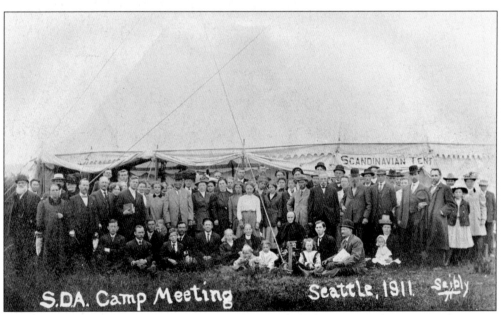

The Seventh-Day Adventists held a camp meeting probably at Green Lake in 1911. This group is shown in front of the Scandinavian tent. (Courtesy Nordic Heritage Museum.)

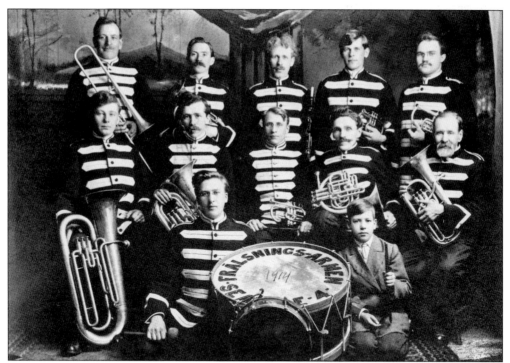

The Salvation Army (*Frälsningsarmén* in Swedish) was very active among Swedish-speaking groups in the cities of the Pacific Northwest. Music, such as this band photographed in 1914, was an important part of their mission. (Courtesy author's collection.)

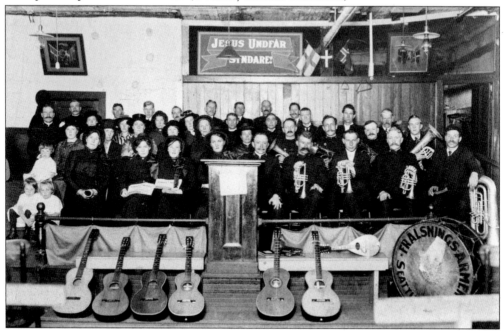

The row of guitars in the foreground, temporarily set aside for this group photograph probably from the 1910s, would normally be in use during a Salvation Army service. The bass drum on the right reads, "*Frälsningsarmén,*" Salvation Army in Swedish. (Courtesy Nordic Heritage Museum.)

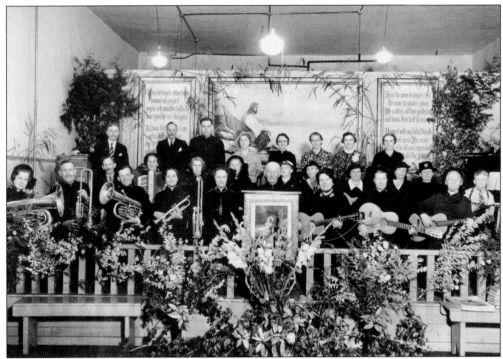

The basement of the Salvation Army's downtown Seattle headquarters was fondly referred to as the *Hallelujahkällaren* (Hallelujah Cellar). (Courtesy Nordic Heritage Museum.)

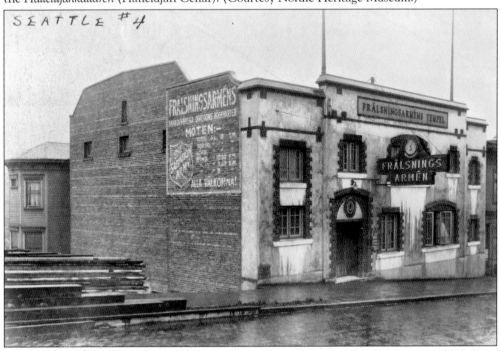

The Salvation Army had several outposts in Seattle. This one (No. 4), photographed about 1930, was located on Terry Avenue. The sign on the side of the building, in Swedish, says "Alla välkomna!" ("Everyone welcome!"). (Courtesy Nordic Heritage Museum.)

Salvation Army outpost No. 3 was located in the Youngstown area of West Seattle, an indication of the large Swedish population in that area. (Courtesy Nordic Heritage Museum.)

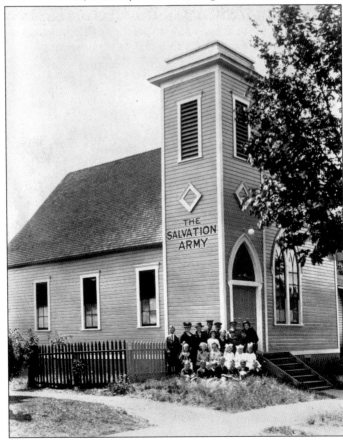

The Salvation Army also had an outpost in Ballard, shown in about 1927. (Courtesy Nordic Heritage Museum.)

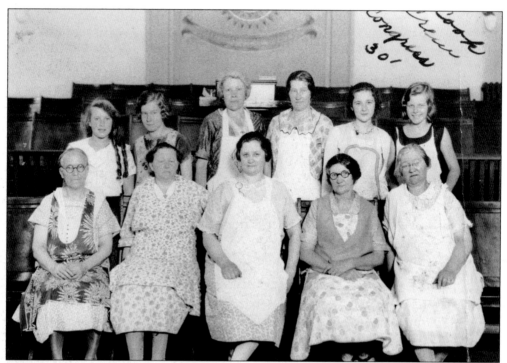

This cook crew helped feed attendees at a Salvation Army Congress held in Seattle in 1930. (Courtesy Nordic Heritage Museum.)

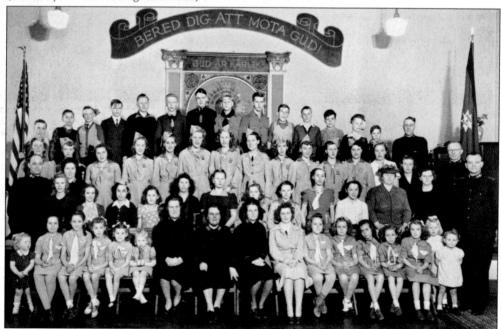

The Salvation Army had a strong presence in the Swedish community in Seattle for many years. This photograph is from a Sunbeam Rally held by Guard Scouts, a youth group, in the 1940s. The banner on the wall behind this group reads "Prepare to Meet God!" in Swedish. (Courtesy Nordic Heritage Museum.)

The Reverend Otto R. Karlstrom founded the Lutheran Mission in 1902. The name was later changed to the Lutheran Compass Mission and today continues its work of serving the disadvantaged as the Lutheran Compass Center in Seattle's Pioneer Square. Reverend Karlstrom is shown here in his waterfront office in 1946. (Courtesy Nordic Heritage Museum.)

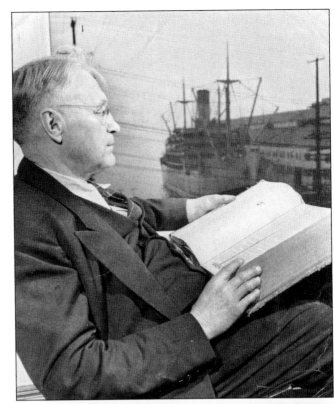

The Millionairs Club was started by Swedish immigrant Martin Johansson who, as this picture indicates, had daily, hands-on involvement with the organization. In this picture, he is sweeping the steps to the charity's early Pioneer Square location. (*Seattle Post-Intelligencer* Collection, MOHAI.)

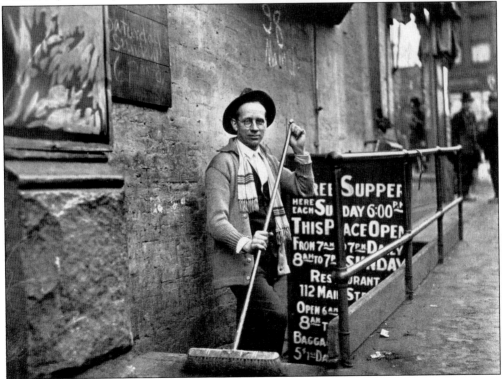

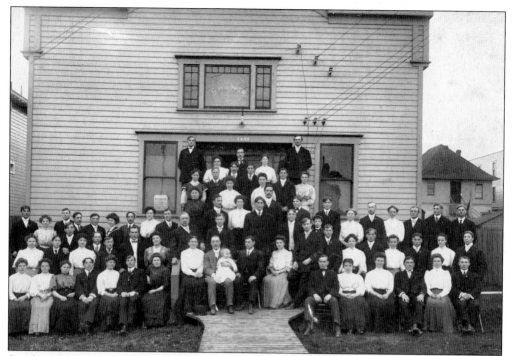

Sveaborg Lodge was a temperance society organized in 1903 by members of the Swedish Finn community in Seattle. In 1920, Sveaborg merged with Ankaret (the Anchor), an insurance society formed in 1915, to become Lodge No. 101 of the Order of Runeberg. The lodge hall was located at 1457 Twenty-second Avenue NW in Ballard. (Courtesy Swedish Finn Historical Society.)

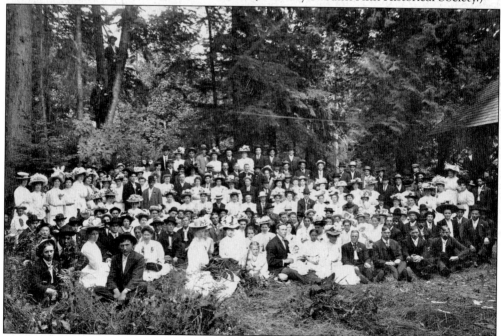

Members of Sveaborg Lodge enjoy a picnic at Ravenna Park. (Courtesy Swedish Finn Historical Society.)

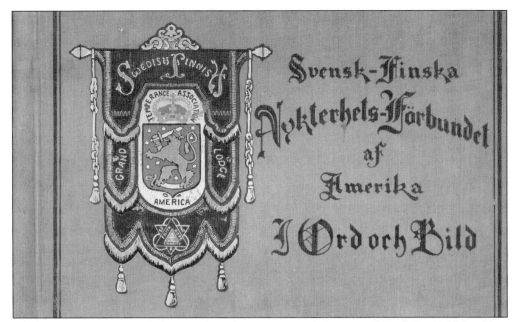

Sveaborg Lodge was part of a larger group of temperance organizations, Svensk-Finska Nykterhets-Förbundet af Amerika (Swedish-Finn Temperance Society of America). The cover of one of the organization's yearbooks is shown here. (Courtesy Charlie Anderson.)

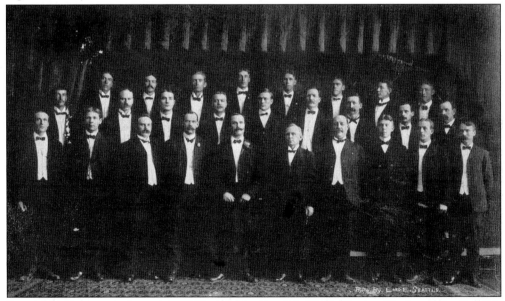

Svea Male Chorus was formed in 1905 when the Swedish Club's Singing Choir and the Swedish Glee Club decided to merge. Here the group is shown in its first formal portrait. A fondness for choral singing was a tradition Swedish and other northern European immigrants brought with them from their home countries. Svea Male Chorus, long affiliated with the Swedish Club (now Swedish Cultural Center) in Seattle, still exists today. Among the founding members were C. F. Wallin (first row, fourth from left), who owned a shoe store with John Nordstrom, and N. B. Nelson (first row, fifth from right), president of the chorus. (Courtesy Claude Nelson and Svea Male Chorus.)

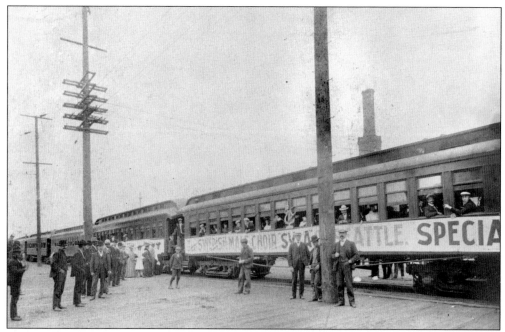

One of the first excursions made by the Svea Male Chorus was to Portland to sing at the Scandinavian Day Festival in June 1905 and help organize the American Union of Swedish Singers, Pacific Coast Division. Here the group prepares to board a special train bound for the Rose City. (Courtesy Claude Nelson and Svea Male Chorus.)

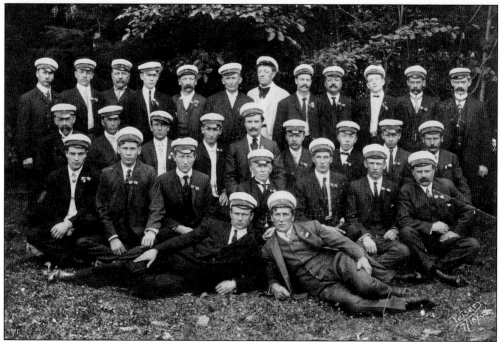

A photographer was often on hand when the Svea Male Chorus performed or played. Here the group enjoys a picnic in Wildwood Park in the wilds of Bellevue in 1905. The white caps are a traditional feature of Swedish male choruses. (Courtesy Claude Nelson and Svea Male Chorus.)

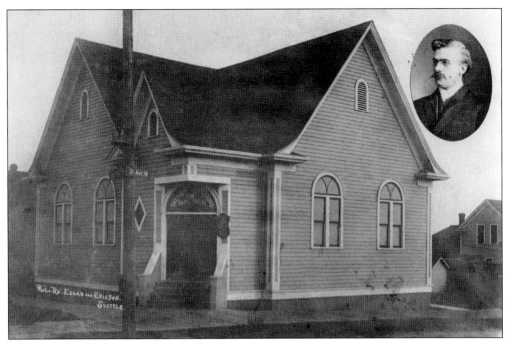

The Ballard Covenant Church was established in 1907 as an offshoot of the First Covenant Church located on Capitol Hill. The sign over the front door reads *Svenska Missionstabernaklet* (the Swedish Mission Tabernacle). The church was located at the southeast corner of Twenty-second Avenue NW and Northwest Sixty-first Street. As the street sign indicates, the street numbering system in Ballard was different at the time this photograph was taken. (Courtesy Nordic Heritage Museum.)

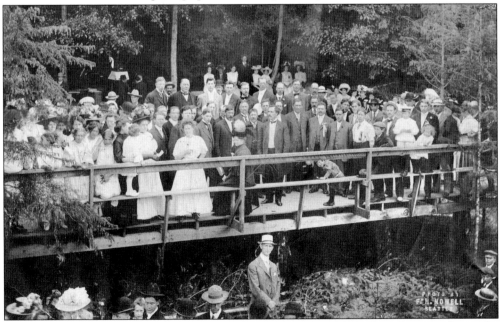

Fortuna Park on Mercer Island, then a forested getaway accessible by ferry from Leschi on the Seattle side of Lake Washington, was a popular picnic spot. Here the Svea Male Chorus enjoys a gathering in 1910. (Courtesy Claude Nelson and Svea Male Chorus.)

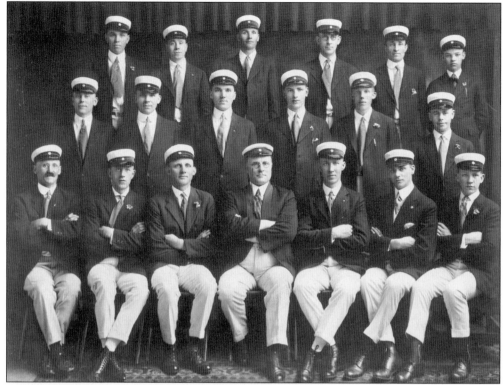

Svea Male Chorus was by no means the only choral group for men in the Seattle Swedish community. Vasa Glee Club sat for a portrait in 1920. (Courtesy Claude Nelson and Svea Male Chorus.)

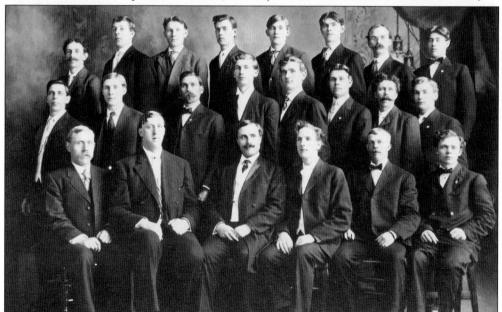

Ballard (a town of its own from its incorporation in 1890 until it became part of the city of Seattle in 1907) had its own Swedish male singing group, the Brage Chorus. (Courtesy author's collection.)

The Alaska Building, the first "skyscraper" in downtown Seattle, was owned by the Scandinavian American Bank, proud to advertise "4% Interest Paid on Savings Deposits" on this promotional postcard. (Courtesy Dave Wolter.)

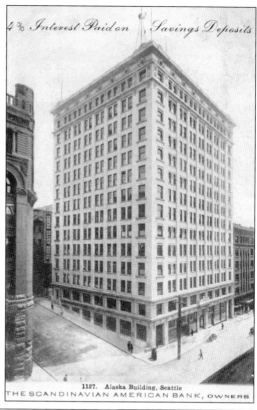

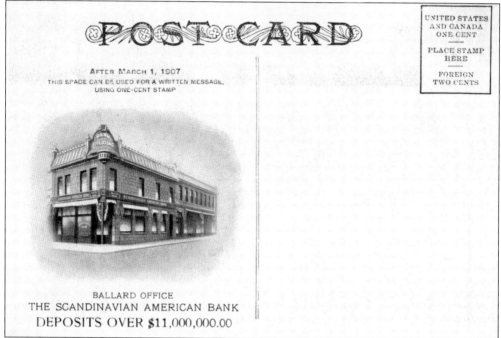

The back of the postcard promotes the Ballard branch of the Scandinavian American Bank. (Courtesy Dave Wolter.)

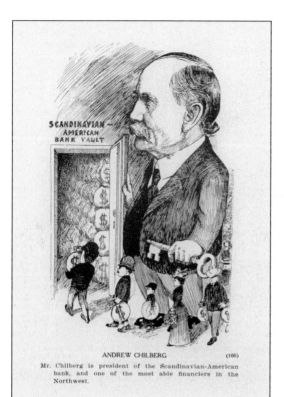

ANDREW CHILBERG (166)

Mr. Chilberg is president of the Scandinavian-American bank, and one of the most able financiers in the Northwest.

Andrew Chilberg was a prominent Seattle businessman, president of the Scandinavian-American Bank, and actively involved in the Swedish American community. A caricature in the *Argus* indicated that Chilberg was part of the city's business elite. (Courtesy Clinton White.)

J. E. Chilberg, brother of Andrew Chilberg, was a prominent businessman in his own right. He served as president of the Alaska-Yukon-Pacific Exposition, which was in its early planning stages when this cartoon was published in 1906. (Courtesy Clinton White.)

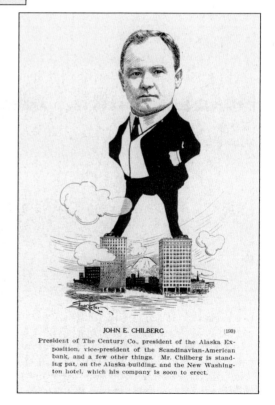

JOHN E. CHILBERG (193)

President of The Century Co., president of the Alaska Exposition, vice-president of the Scandinavian-American bank, and a few other things. Mr. Chilberg is standing pat on the Alaska building, and the New Washington hotel, which his company is soon to erect.

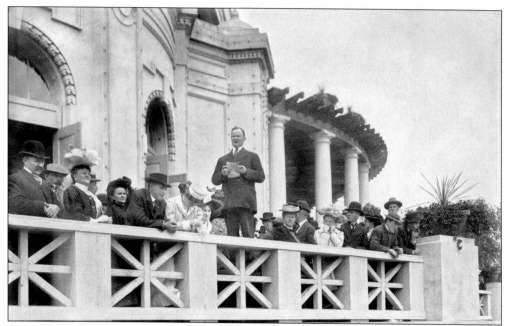

J. E. Chilberg, president of the planning committee for the Alaska-Yukon-Pacific Exposition, addresses stockholders in September 1908. Local interest in the exposition was great, and funds raised by the sale of shares considerably exceeded the committee's expectations. (Courtesy UW Special Collections, UW26891z.)

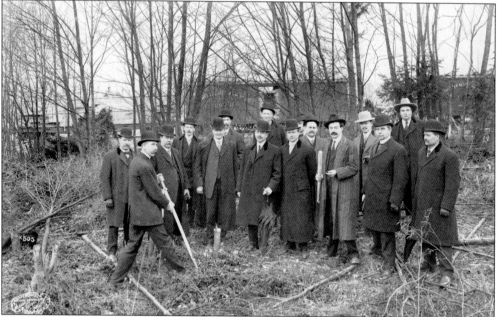

Planning for what was to be the Alaska-Yukon-Pacific Exposition (AYPE) began as early as 1905 when Swedish immigrant O. G. Chealander proposed an Alaska exhibit to his friend J. E. Chilberg, president of the Alaska Club and vice president of the Scandinavian American Bank in Seattle. The initial idea soon expanded. The groundbreaking ceremony for the Swedish Building at the AYPE was held on February 29, 1908. (Courtesy UW Special Collections, Nowellx505.)

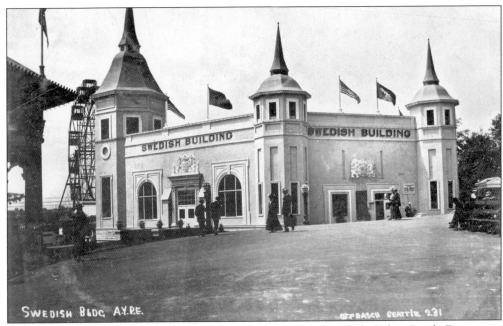

Many states and foreign countries had buildings of their own at the Alaska-Yukon-Pacific Exposition. Here is a view of the Swedish Building from ground level. (Courtesy Clinton White.)

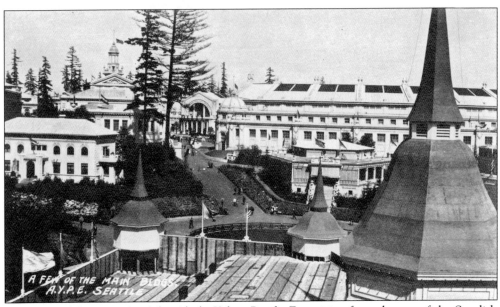

This view of the grounds of the Alaska-Yukon-Pacific Exposition from the top of the Swedish Building shows a few of the main buildings as well as the Swedish Building's spires. (Courtesy Clinton White.)

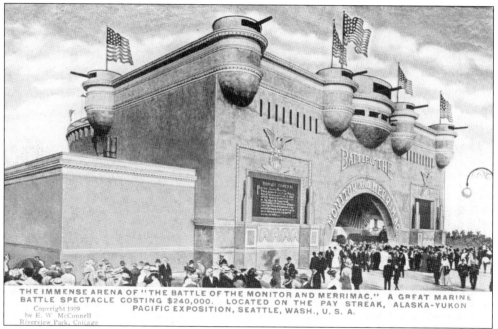

THE IMMENSE ARENA OF "THE BATTLE OF THE MONITOR AND MERRIMAC." A GREAT MARINE BATTLE SPECTACLE COSTING $240,000. LOCATED ON THE PAY STREAK, ALASKA-YUKON PACIFIC EXPOSITION, SEATTLE, WASH., U. S. A.
Copyright 1909
by E. W. McConnell
Riverview Park, Chicago

One of the popular attractions of the AYPE was the reenactment of the Civil War Battle of the *Monitor* and *Merrimac*. This postcard was clearly a marketing tool: "The immense arena of 'The Battle of the Monitor and Merrimac.' A great marine battle spectacle costing $240,000. Located on the Pay Streak, Alaska-Yukon-Pacific Exposition, Seattle, Wash., U.S.A." The Swedish connection is that the USS *Monitor* was designed by Swedish inventor and entrepreneur John Ericson. (Courtesy Clinton White.)

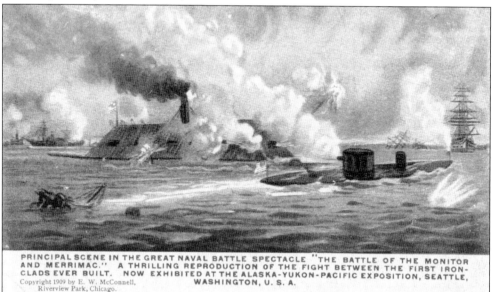

PRINCIPAL SCENE IN THE GREAT NAVAL BATTLE SPECTACLE "THE BATTLE OF THE MONITOR AND MERRIMAC." A THRILLING REPRODUCTION OF THE FIGHT BETWEEN THE FIRST IRON-CLADS EVER BUILT. NOW EXHIBITED AT THE ALASKA-YUKON-PACIFIC EXPOSITION, SEATTLE, WASHINGTON, U. S. A.
Copyright 1909 by E. W. McConnell,
Riverview Park, Chicago.

Here is a glimpse of what the public could expect inside. The postcard caption reads, "Principal scene in the great naval battle spectacle 'The Battle of the Monitor and Merrimac.' A thrilling reproduction of the fight between the first ironclads ever built. Now exhibited at the Alaska-Yukon-Pacific Exposition, Seattle, Washington, U.S.A." (Courtesy Clinton White.)

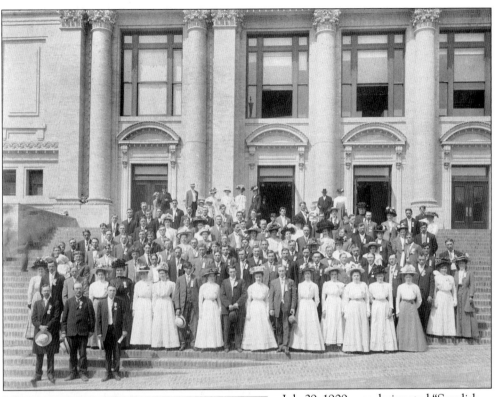

July 29, 1909, was designated "Swedish-Finnish Temperance Association of America Day" at the Alaska-Yukon-Pacific Exposition. (Courtesy Swedish Finn Historical Society.)

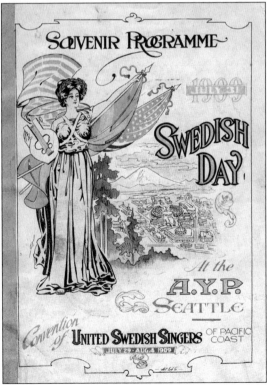

The convention of the United Swedish Singers of the Pacific Coast was timed to coincide with the AYPE, with celebrations and concerts extending over two days. Here is the cover of the *Souvenir Programme*; the convention itself was held from July 29 to August 4, 1909. The Swedish Day assembly planned to feature an address by the Swedish American governor of Minnesota, John A. Johnson, whose train was delayed in Spokane. Governor Johnson did, however, arrive in time for Minnesota Day a few days later. (Courtesy Claude Nelson and Svea Male Chorus.)

Special music was written for Swedish Day, "JubelKantat för Svenska Dagen 31 Juli 1909" (Jubilee Cantata for Swedish Day, July 31, 1909). Swedish faces featured on this program cover include the legendary 19th-century singer Jenny Lind, top; the inventor John Ericson; and Hjalmar Edgren, professor of Sanskrit at Yale and translator of Longfellow's "Evangeline" into Swedish. The music was by Adolph Edgren with libretto by Emanuel Schmith. An advertisement inside the program indicates that a bookstore carrying Swedish books, *Svenska Bokhandeln* (the Swedish Bookstore), was in business on Pike Street at that time. (Courtesy Claude Nelson and Svea Male Chorus.)

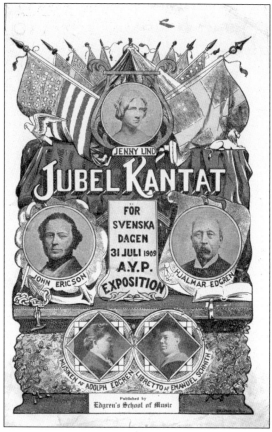

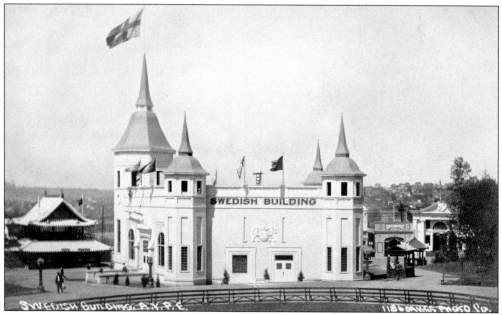

This slightly elevated view of the Swedish Building at the AYPE shows off its spires, as well as the large Swedish flag flying from the highest one. (Courtesy Clinton White.)

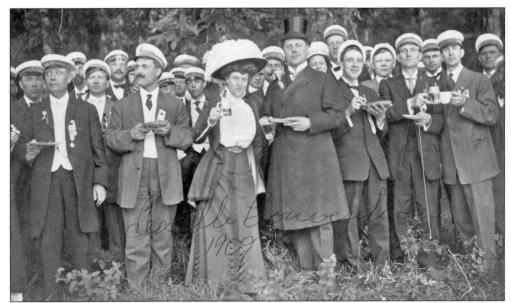

Swedish opera singers Madame Hellström Oscar (center, in white hat) and Mr. Oscar seem to be having a good time with members of Svea Male Chorus at the picnic held at Fortuna Park in connection with the Union of Swedish Singers of the Pacific Coast convention and Swedish Day at the Alaska-Yukon-Pacific Exposition. (Courtesy UW Special Collections, UW26888z.)

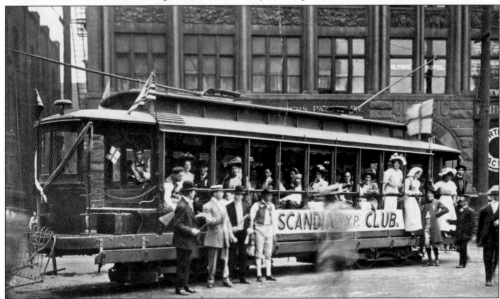

Let's go to the AYPE. The Scandia Club apparently organized a streetcar outing to the Alaska-Yukon-Pacific Exposition, with a starting point in Pioneer Square where this photograph was taken in front of the Great Northern Pacific Railway building. The banner, Swedish and American flags, and dress-up clothes suggest this was a special occasion. Note the Olympic Hotel sign in the second-story window; obviously this wasn't the hotel with that same name built in 1924 on the original site of the University of Washington, later known as the Four Seasons Olympic and now as the Fairmont Olympic. This was one of several hotels in the Pioneer Square neighborhood at that time which catered to railroad workers and travelers. (Courtesy author's collection.)

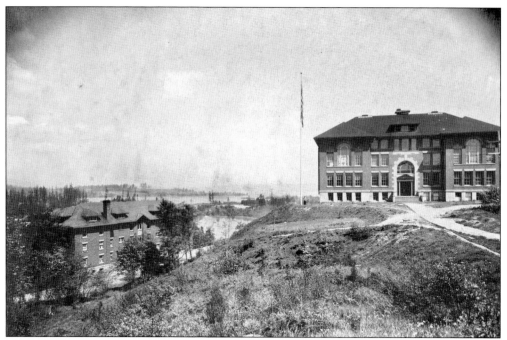

Adelphia Hall and the dormitory of Adelphia College, founded in 1905, are shown. While an independent educational institution, the college had close ties to the Swedish Baptist church. The property and buildings were eventually sold to Seattle Preparatory School. (Courtesy Nordic Heritage Museum.)

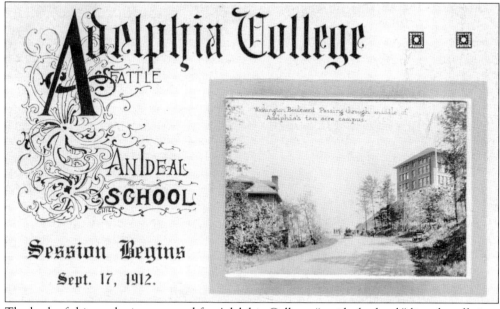

The back of this marketing postcard for Adelphia College, "an ideal school," lists the offerings for the fall 1912 session: "Adelphia College and School of Commerce fits young people for life. Bookkeeping, Short-hand, Typewriting, Penmanship, Academic Department and Conservatory of Music. Board and room at low cost in modern Dormatory [sic], and under Christian Supervision. Write for Catalogue." (Courtesy Clinton White.)

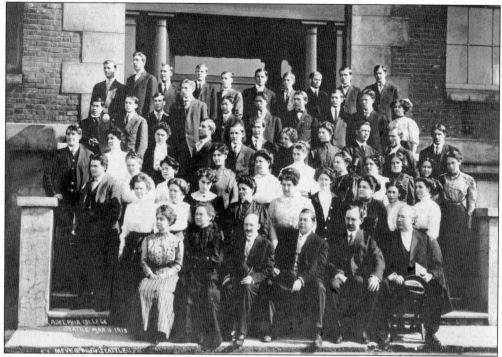

Students and faculty members pose at the entrance to coeducational Adelphia College in 1910. (Courtesy author's collection.)

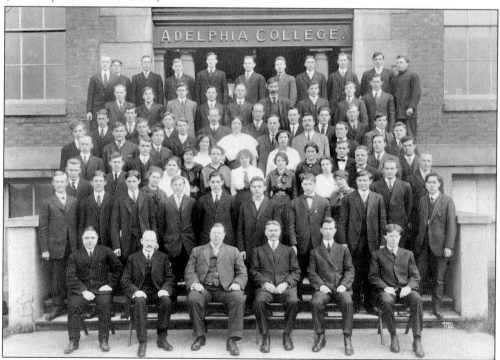

Students at Adelphia College pose on the entrance stairway *c.* 1930. (Courtesy Nordic Heritage Museum.)

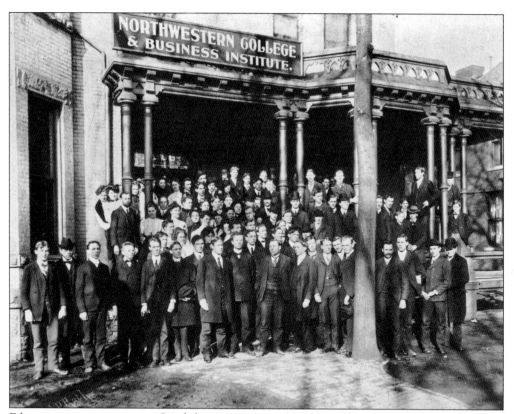

Education was important to Swedish immigrants and to their offspring. Northwestern College and Business Institute, founded in 1903, was sponsored by the Covenant Church. (Courtesy author's collection.)

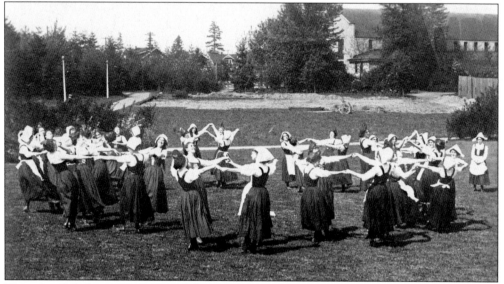

These Swedish dancers were part of the 1912 May Fete, for many years an annual tradition at the University of Washington. The Washington State Legislature established a Scandinavian department at the University of Washington in 1909. (Courtesy UW Special Collections, UW22021z.)

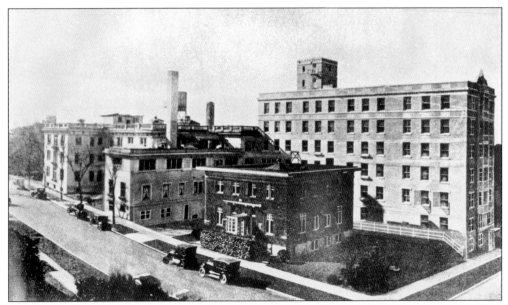

Swedish Hospital was founded in 1908 by a group of 11 mostly Swedish American citizens. The hospital is shown in 1916 in the building it acquired in 1912 between Columbia Street and Summit Avenue. (Courtesy Nordic Heritage Museum.)

The leading force in the group of 11 men (all members of the Swedish Club in Seattle) that founded Swedish Hospital was Dr. Nils Johansson. (Courtesy Nordic Heritage Museum.)

Two

At Work and at Play

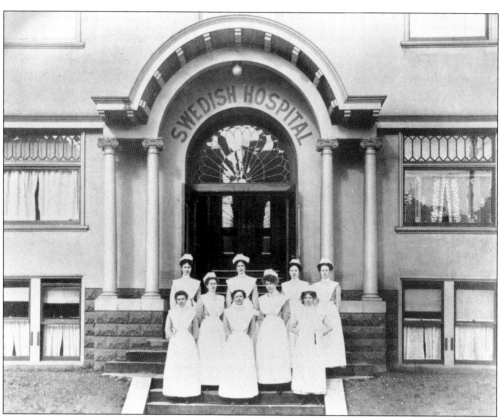

Graduating nurses pose on the front steps of Swedish Hospital at its original location on Belmont Avenue in 1910. (Courtesy Nordic Heritage Museum.)

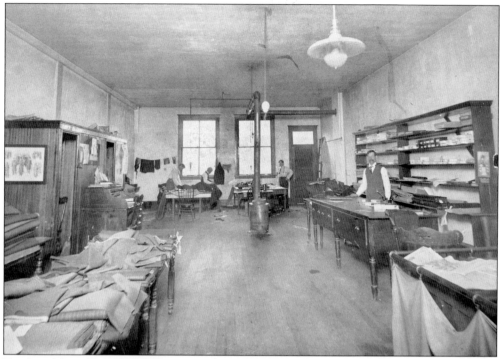

Frank and Sven Engquist are shown inside the Frank Engquist tailor shop, which was located in the Triangle Building on Ballard Avenue. (Courtesy Nordic Heritage Museum.)

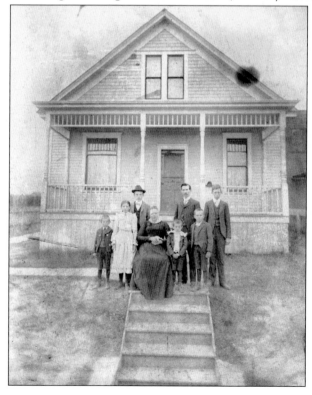

Tailor Frank Engquist and his family stand outside their home in Ballard at Twenty-fourth Avenue and Fifty-ninth Street NW. (Courtesy Nordic Heritage Museum.)

In 1901, a young Swedish immigrant named John Nordstrom formed a partnership with shoemaker Carl F. Wallin, whom he had met in Alaska, to open a shoe store on Pike Street in downtown Seattle. Here the store's helpful staff of sales personnel stands ready to help customers. Following the Swedish tradition of assigning characteristic nicknames to people with similar last names, local Swedes often referred to their compatriot John as "Shoe Nordstrom." (Courtesy Nordic Heritage Museum.)

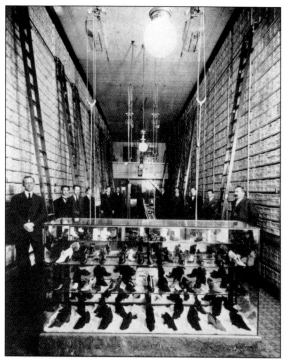

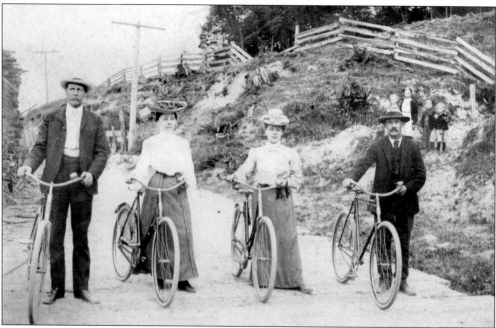

These bike riders are enjoying a Sunday afternoon outing somewhere in West Seattle (in the vicinity of Pigeon Hill where many Swedes lived at that time). The young woman second from left is Mathilda Nordborg, who emigrated from Sweden in 1903. On either side of her are her sponsors, Mr. and Mrs. A. Abrahamson, who were also Swedish immigrants and owned a brickyard in West Seattle. Most of the streets were paved in brick in those days. This picture was probably taken not long after Mathilda's arrival in Seattle. (Courtesy Lura Belle Anderson.)

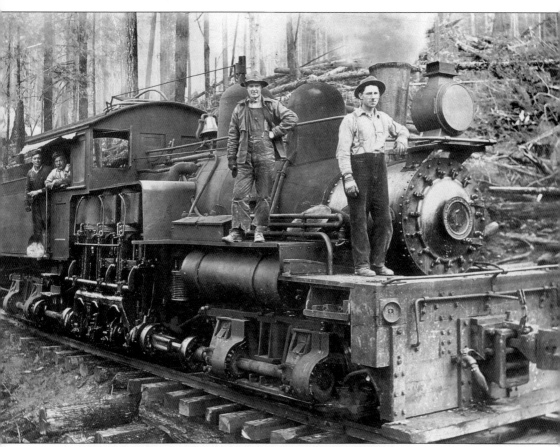

Julius Arvid Alberg (1883–1932) was born in Sweden and immigrated to America in 1898. He worked as a logger but lost his leg in a train accident. With the compensation he received, he was able to attend college for a year at Pacific Lutheran University and then found employment as a bookkeeper at a sawmill. He eventually owned a number of sawmills at Hazel, Port Angeles, Anacortes, and Burnaby (with a sales office in Fremont in Seattle) as well as the train pictured here. His son Thomas Alberg ran a successful real estate business in Seattle until his death in 2007 at the age of 91. (Courtesy family of Thomas Alberg.)

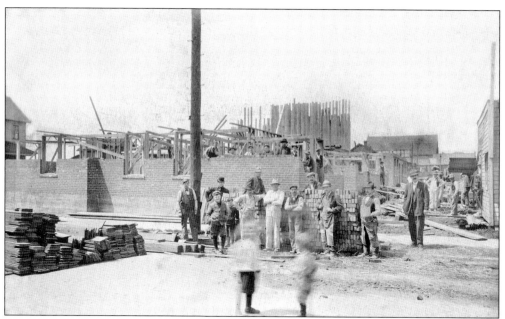

Many Swedish immigrants worked in construction-related trades. Adolf Anderson, employed at the time by Swedish contractor Otto Roseleaf, was part of the crew pictured at this construction site at Third Avenue and Pine Street in May of 1911. (Courtesy Charlie Anderson.)

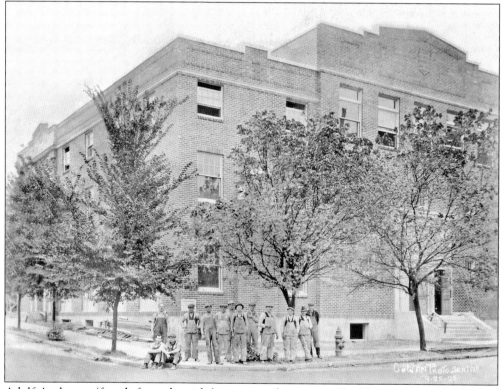

Adolf Anderson (fourth from the right) is among this group of builders posing in front of an unidentified Seattle building in 1929. (Courtesy Charlie Anderson.)

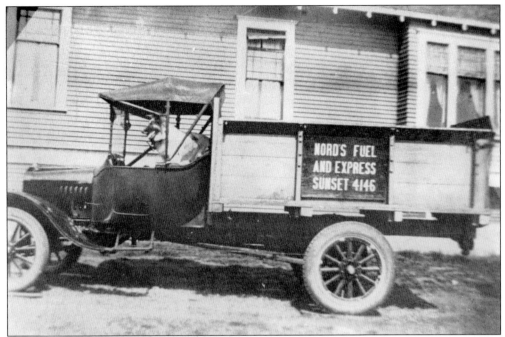

In the first decade of the 1900s, cars began to appear on Seattle streets. The first Model T with a gearshift in the city was reportedly acquired by Swedish immigrant Eric Nord, who operated Nord's Fuel and Express in 1909. The name of the dog is not known. (Courtesy Nordic Heritage Museum.)

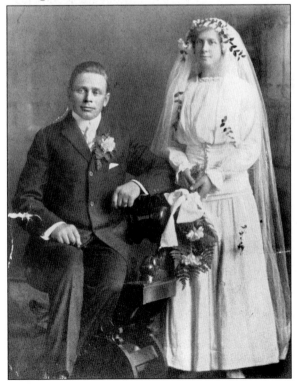

Felix and Matilda Johnson, shown on their wedding day, were both born in Sweden. After leaving Sweden, Felix lived in Alaska where he worked as an ore hauler; Matilda emigrated at the age of 12. After returning to Sweden to visit their parents, they met on the long boat trip back. By the end of the voyage, they were engaged. After their first three children were born in Alaska, they moved to Seattle, bringing their car with them. They settled first in Ballard then in West Seattle, where they were proud to own one of the first cars in that neighborhood. Felix worked as a bricklayer on many projects in Washington state, including the Grand Coulee Dam, while Matilda raised their four children, three girls and a boy. (Courtesy Lillian Brubaker.)

Anna Carlson, Karl-Olof Carlson, and their infant daughter, Ruth, emigrated from the Swedish province of Jämtland. There were enough immigrants from that Swedish province in the Seattle area to form their own organization, Jamtli. This photograph, taken on the porch of the Carlsons' home on Lake Sammamish, is from 1914. (Courtesy Carolyn Purser.)

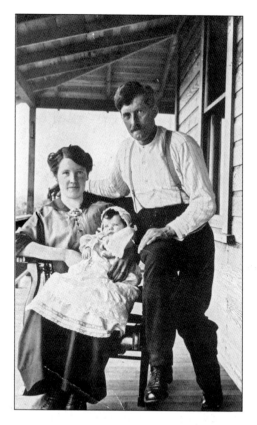

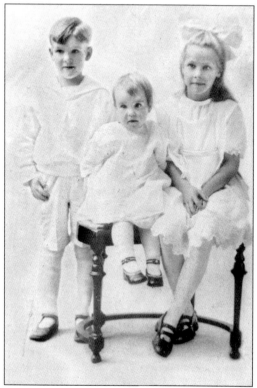

Three offspring of Swedish immigrants Anna and Carl Bjork were born in Ballard; Wilbert (born in 1910), Lorraine (born in 1911), and Doris (born in 1917, nicknamed "Dode") all graduated from Ballard High School. Will became a naval engineer who taught at Massachusetts Institute of Technology and the Naval Academy. Lorraine was a nurse at Swedish Hospital and later the Norse Home until she retired at age 85. Dode was assistant manager at Washington Mutual in Ballard for many years. (Courtesy Julie Albright.)

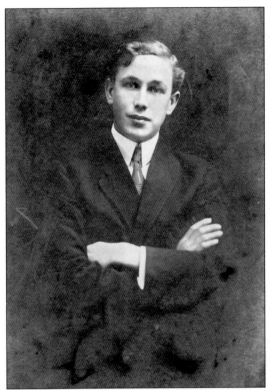

Carl Herman Benson and his brother Ernest became business partners in a flower shop at 4320 Fourteenth Avenue NW (present-day University Way) in 1914. Carl, who emigrated from the Swedish province of Skåne in 1906, managed the store. When their venture folded two years later, Carl took a job as foreman of an agricultural experiment station in Sitka, Alaska, and returned to Seattle in 1921 to start his own florist business, the Pines Floral Company in Kirkland. (Courtesy Janet Park.)

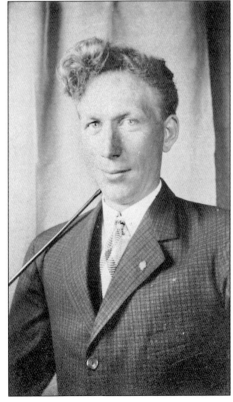

Ernest Benson emigrated from his native Sweden in 1902. For two years, he operated a flower shop in the University District with his younger brother Carl. Ernest raised the flowers in a nearby greenhouse on land where Husky Stadium stands today. Because of the expansion of the University of Washington, Ernest moved his operation to Sand Point. Forced to move again, he bought property in Lake City, where for many years he raised flowers, specializing in dahlias. (Courtesy Janet Park.)

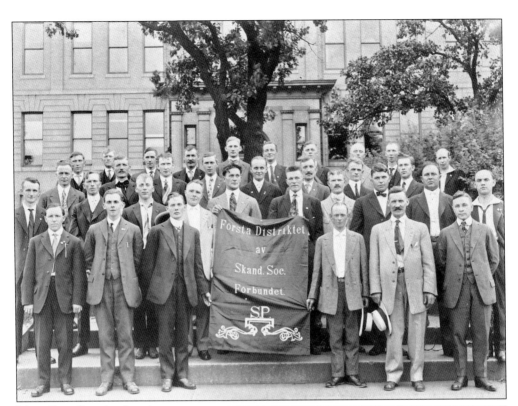

Many Scandinavian immigrants were union members and played an active role in the growing labor movement in the Pacific Northwest in the late 1800s and early 1900s. This group (pictured in the 1910s) displays a banner with the name of their organization. (Courtesy Christy Wicklander.)

The Industrial Workers of the World (IWW), popularly known as the "'Wobblies," had many Swedish members. Half of the lyrics in this songbook, printed in Seattle about 1924, are in Swedish, while the remaining song texts are in Danish and Norwegian. The most famous Swedish immigrant associated with the IWW was of course Joe Hill, executed in Utah in 1915 for what many believe to be a false murder charge. (Courtesy Randy Nelson.)

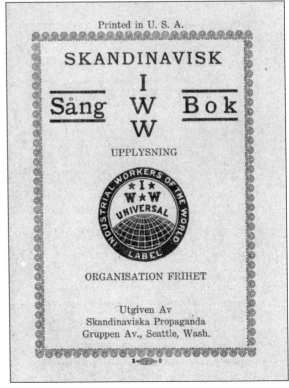

This group of Swedish Finns (immigrants from Finland who were part of that country's Swedish-speaking minority) relaxes outdoors in 1916, probably on a Sunday afternoon. Most likely they were members of Emmaus Evangelical Lutheran Church in Ballard. (Courtesy Bill Engstrom.)

A picnic basket is at the center of this group about 1905, which includes Nels and Mathilda Hallstrom (first row, center) and friends. (Courtesy Lura Belle Anderson.)

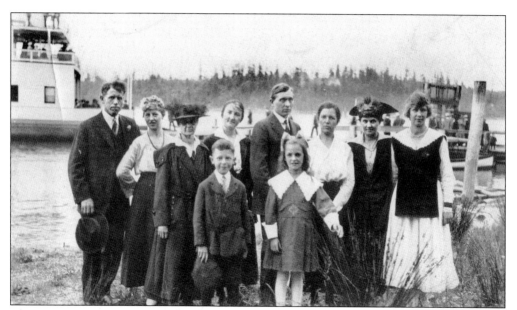

This group of Swedes may be waiting for the ferry at Leschi to go to Mercer Island for a Sunday outing in 1917, or perhaps they've just returned. Elof Nordborg (far left) emigrated from Sweden in 1905; his nickname was "Uncle Curly." In the center are Nels and Mathilda Hallstrom and their two children, Albert and Ethel. (Courtesy Lura Belle Anderson.)

Albert Halstrom and his sister Ethel enjoy camping about 1920. (Courtesy Lura Belle Anderson.)

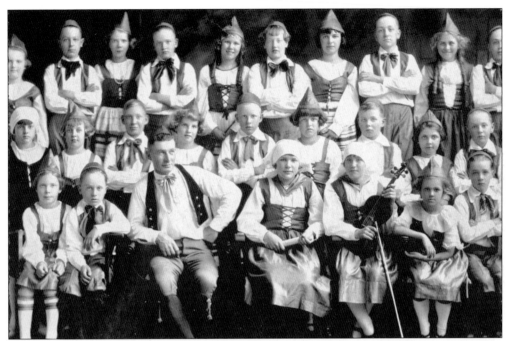

Albert Halstrom (third row, second from left) was part of a dance group probably organized by the Swedish Club in the early 1920s. (Courtesy Lura Belle Anderson.)

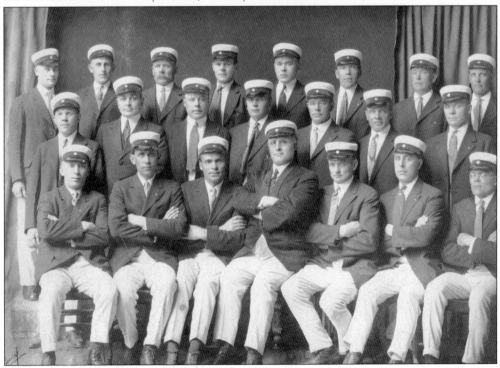

The ranks of the Echo Male Chorus, shown here in 1928, were mainly drawn from the Swedish Finn community. Many members of the chorus also sang in the Vasa Glee Club; the two groups had the same director, C. H. Sather. (Courtesy Swedish Finn Historical Society.)

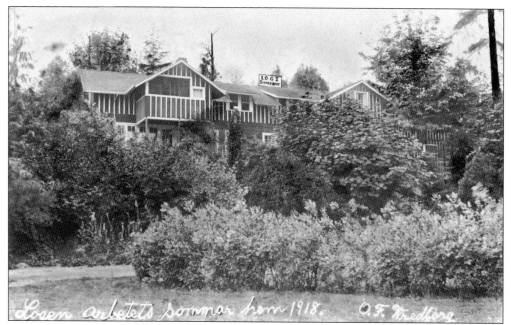

Losen arbetets sommar hem 1918. O.F. Medberg.

Arbetets Lodge, affiliated with the International Order of Good Templars (IOGT), a temperance organization, had a "summer home" building in the Denny-Blaine area of Seattle (the former Kittinger home) with canoe house, meeting rooms, and boarding rooms. This photograph is from 1918. At some point, someone outlined the IOGT sign on the roof on the photographic negative. (Courtesy North Star Lodge No. 2.)

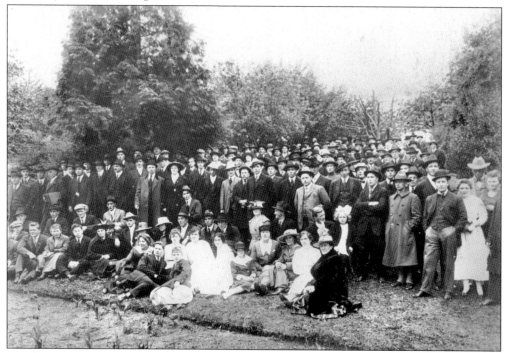

Members of Arbetets Lodge gathered at their summer home in the Denny-Blaine area of Seattle on May 3, 1918. (Courtesy North Star Lodge No. 2.)

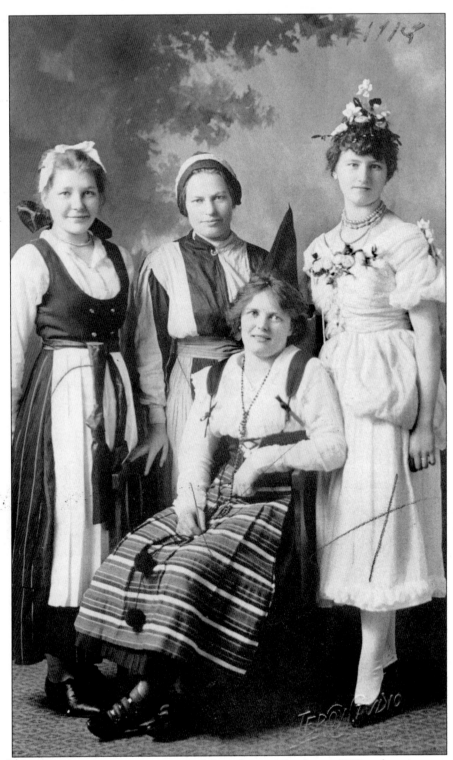

This quartet of young immigrant women had their photograph taken in 1918, perhaps in connection with a lodge function. (Courtesy Swedish Finn Historical Society.)

O. O. O. O.

You are cordially invited to attend a

Series of Dances

given every Thursday evening

by the

Order of Vasa

at

Douglas Hall, Odd Fellows Temple

Tenth and East Pine

Grand Opening

Thursday, October twenty-third, nineteen nineteen

with a

Masque Ball

♣ ♣ ♣

Good prizes will be given

Best four-piece Orchestra
in the city

Gentlemen, fifty-five cents
Ladies free

Refreshments served

◇ ◇ ◇

Committee

C. A. HEDLUND	OSCAR JOHNSON	HATTIE HALLEN
OTTO BOMAN	HUBERT LEAF	INGA JOHNSON
EINAR CARLSON	LUDWIG HEGSTROM	MARGUERITE SIPPLE
CARL CONRAD	EDNA SIPPLE	ESTHER SWANSON
MARIE FAHLSTROM		LAVINIA LINDSTROM

This nicely printed program announces a series of dances held by the Order of Vasa at the Odd Fellows Temple on Capitol Hill. Lavinia Lindstrom (whose name is listed as a committee member) was an active member of Vasa, especially as a young woman growing up in Seattle. (Courtesy Dave Wolter.)

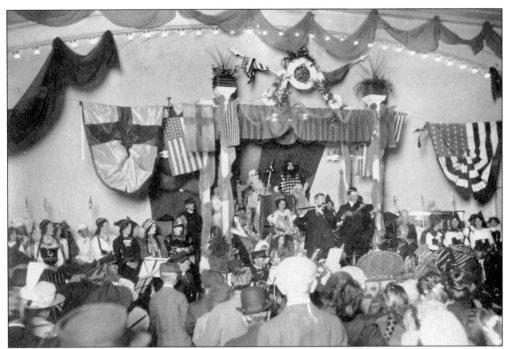

The Order of Vasa, a fraternal and benefit organization with several lodges in Seattle and the surrounding area, hosted many elaborate events involving theater and music. This festive occasion was held about 1919. (Courtesy Dave Wolter.)

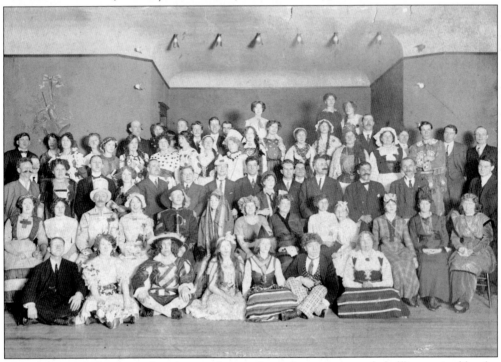

This photograph shows another theatrical event (or perhaps masquerade ball) organized by the Order of Vasa probably in the late 1910s. (Courtesy Dave Wolter.)

L. D. (Lars Daniel) Gustafson, right, worked on a Seattle streetcar for a few years in the 1910s. (Courtesy Charlie Anderson.)

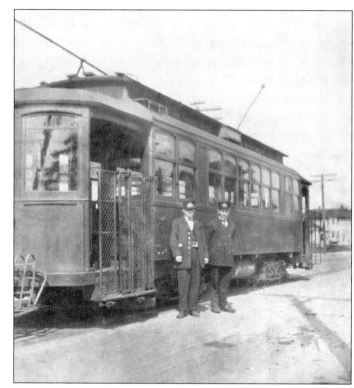

This group (all men with the noticeable exception of the woman holding an infant in the first row) is probably part of the Order of Vasa, which met at the International Order of Odd Fellows (IOOF) Temple on Capitol Hill in the 1910s. (Courtesy Dave Wolter.)

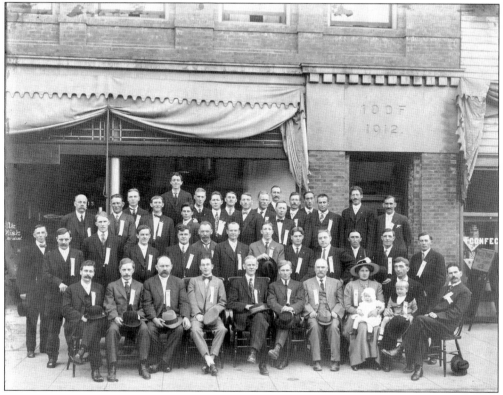

Christina (Carlson) and Andrew Malm built a number of houses on Railroad Avenue (now Fourteenth Avenue NW) in Ballard near Sixtieth Street NW. This was the "first house." (Courtesy Dave Wolter.)

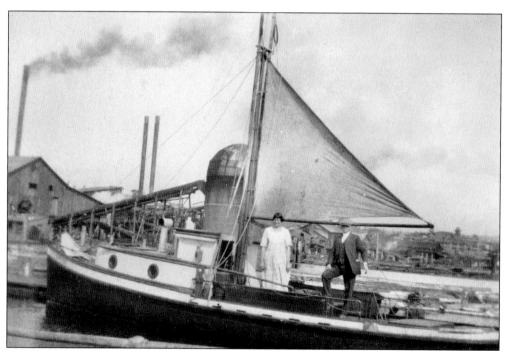

Hanna (Carlson) and husband John "Jack" Johnson pose on their boat near the Ballard shingle mill probably in the 1920s. (Courtesy Dave Wolter.)

Ruth (Carlson) Bailey (second from left) took part in a Vasa lodge performance during the 1930s. (Courtesy Dave Wolter.)

Swedes have always enjoyed summer picnics, and the Carlson family was no exception. Here the family (including C. E. Carlson at far left and his daughter Betty [Carlson] Wolter on the right) gather in upper Golden Gardens in the 1950s. (Courtesy Dave Wolter.)

When immigrants first arrived in Seattle, they often lived in boardinghouses such as this one, Johanson's Boarding House on Boren Avenue. Many such boardinghouses catering to immigrants, such as the Kalmar Hotel at Sixth Avenue and James Street (built in 1881 and razed in 1962), could be found in the city. (Courtesy Swedish Finn Historical Society.)

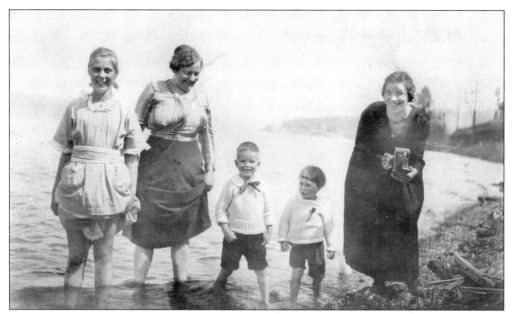

This happy group cools their feet in Lake Sammamish at Vasa Park in the 1920s. From left to right are Alli (Carlson) Benson (who was born in Åland), Sigrid ?, Holger Berg, Hakon Berg, and Hilmi ? (with camera). (Courtesy Swedish Finn Historical Society.)

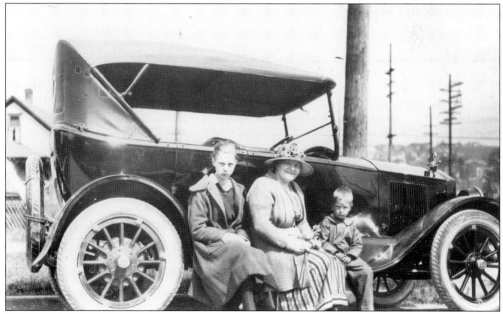

Cars were becoming a bit more common on Seattle streets in the 1920s when this photograph of Alli (Carlson) Benson (left), Sigrid ? (center), and little Hakon Berg (right) was taken. (Courtesy Swedish Finn Historical Society.)

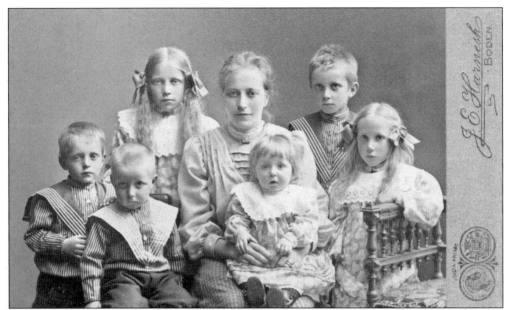

Regina Enbom Nilsson emigrated from Boden, Sweden, in 1913 with her husband and their six children, shown in a studio portrait taken in Sweden. The family first lived in Halifax, then moved to Nanaimo on Vancouver Island. Regina died in Canada before the rest of the family settled in Seattle in 1926. Because the family immigrated to the United States by way of Canada, their papers named them as citizens of the British Commonwealth. (Courtesy Clinton White.)

After arriving in Seattle, the Nelson family (the spelling was changed from the Swedish Nilsson) lived in a house on Eastlake, which later became part of Covey Laundry. Here father John Nelson (Johann Petter Nilsson) is shown inside the family home with his children who still lived in Seattle: daughters Elsa, Edith, Olga, and Ivy (born in North America) and sons Hjalmar and Hilding. (Courtesy Clinton White.)

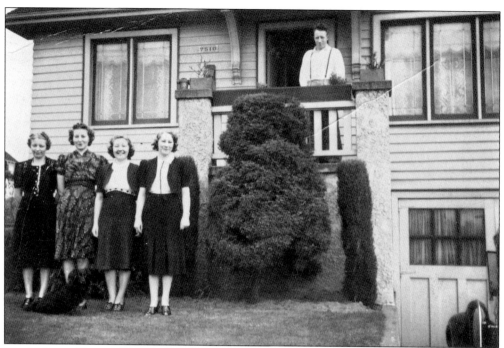

The Nelson siblings, all grown up, are pictured in front of Levi and Leah Wickstrom's house on Northwest Sixteenth Avenue in Ballard. From left to right are Edith, Ivy, Elsa, and Olga, with brother Hilding on the porch. (Courtesy Clinton White.)

When Esther Olson (right) arrived in Seattle from Sweden in the late 1920s, her Swedish American relatives (pictured here from left to right)—Nels and Mathilda Halstrom, their daughter Esther, and son Albert—held a party to welcome her to America. (Courtesy Lura Belle Anderson.)

The confirmation class of 1923 is pictured at Emmaus Evangelical Lutheran Church. In the first row, second from the left is Signe Anderson. The church began as Evangelisk-Lutherska Svensk-Finska Församlingen (Evangelical Lutheran Swedish-Finnish Congregation) in 1909. The church purchased a lot on Northwest Sixty-fifth Street in 1910, and the church building was completed in 1915. Emmaus was the first Swedish Finn congregation to hold services in English. The church later merged with St. John's Lutheran (a church with Danish-American heritage on Phinney Avenue) in 1967. (Courtesy Bill Engstrom.)

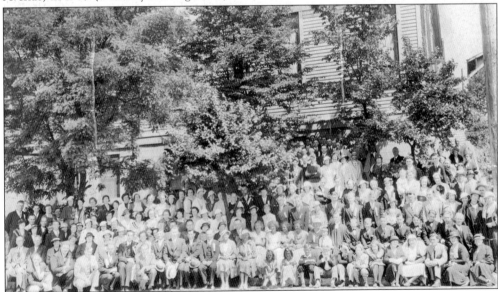

A group of church members gathers outside Emmaus Evangelical Lutheran Church. (Courtesy Swedish Finn Historical Society.)

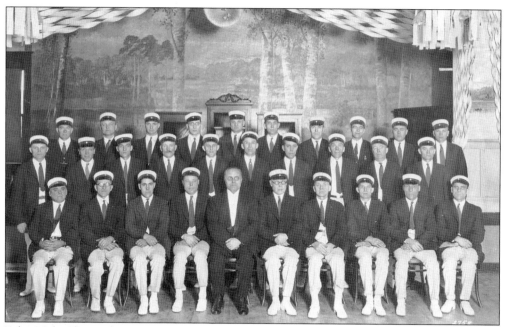

Echo Male Chorus drew its membership from the community of Swedish-speaking immigrants from Finland. The chorus is shown in a 1928 photograph. (Courtesy Swedish Finn Historical Society.)

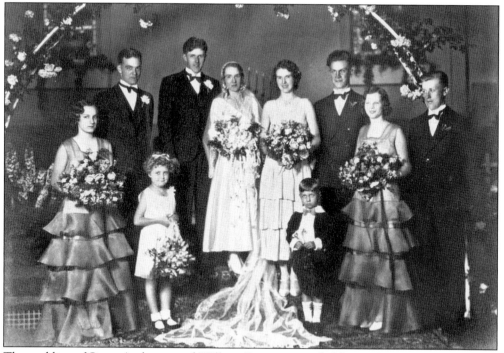

The wedding of Signe Anderson and William Engstrom was held at Emmaus Lutheran Church in 1931. Note the beautiful archway decorated with fresh flowers. The Engstroms later ran a bakery at the corner of Twenty-fourth Avenue and Eightieth Street NW in Ballard for many years. (Courtesy Bill Engstrom.)

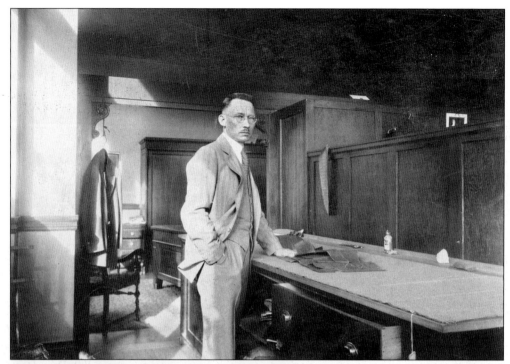

At one time, there were more than 200 tailors in the city of Seattle. Gus Sundberg, shown in his shop in the 1930s, operated his fine tailoring business in the American Bank Building at Second and Madison. (Courtesy Nordic Heritage Museum.)

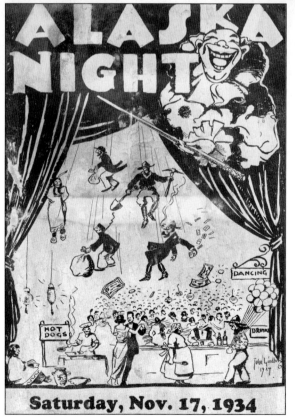

The fund-raising bazaar known as Alaska Night was a popular, annual event at the Swedish Club. (Courtesy Swedish Cultural Center.)

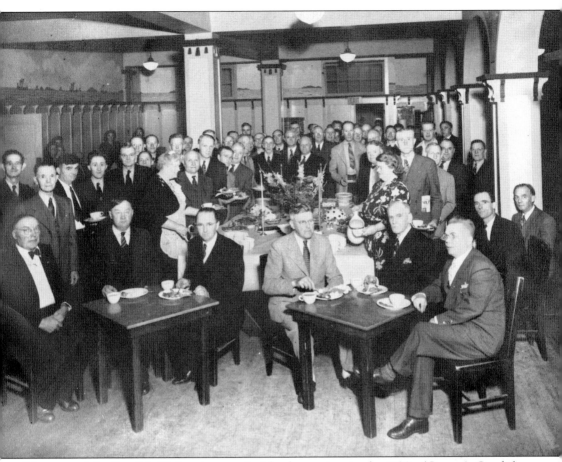

The men of the Swedish Club enjoy a *smörgåsbord* sometime in the 1930s. (Courtesy Swedish Cultural Center.)

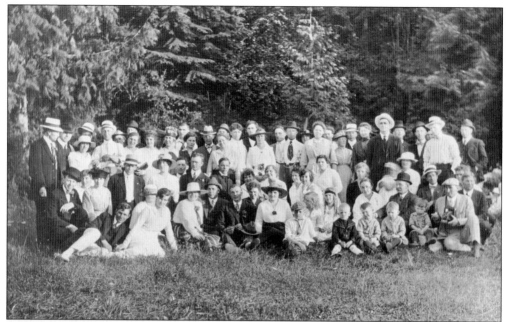

Members of North Star Lodge No. 2 of the International Order of Good Templars (IOGT) gathered, probably in a Seattle park, in 1915. (Courtesy North Star Lodge No. 2.)

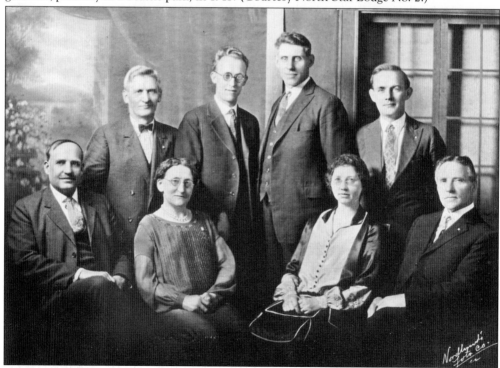

This studio portrait from the 1920s shows some of the members of North Star Lodge No. 2. From left to right are (first row) Emil Landquist, Emma Olson, Anna Whalen, and Olaf Whalen; (second row) Victor Landberg, Arvid Carlson, Rikard Sahlin, and Carl Chilberg. (Courtesy North Star Lodge No. 2.)

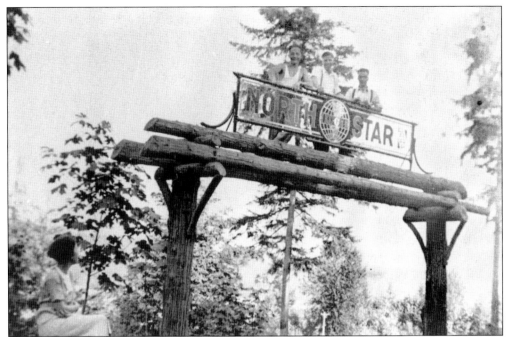

In 1926, North Star Lodge No. 2 began developing a *sommarhem* (summer home) on Mercer Island. Members built small cabins for their families to use and a pavilion for group activities. The entrance sign to the park (still standing) was built by Alex B. Hagg; his three sons (from left to right: Alvin, Bert, and Arnie Hagg) are pictured here. (Courtesy North Star Lodge No. 2.)

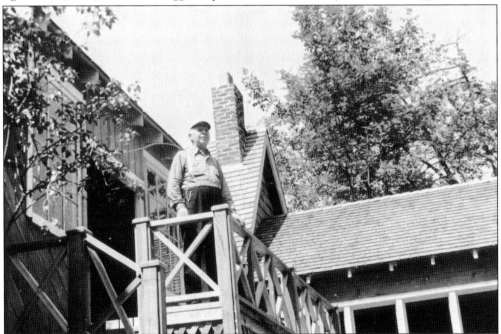

Construction of the pavilion at the summer home of North Star Lodge No. 2 on Mercer Island continued in 1936 and 1937 under the watchful eye of designer/builder Alex B. Hagg. (Courtesy North Star Lodge No. 2.)

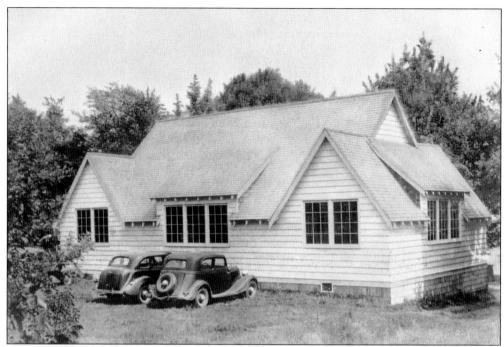

The pavilion at the North Star Lodge No. 2 summer home on Mercer Island was completed in 1938. The building looks much the same today. (Courtesy North Star Lodge No. 2.)

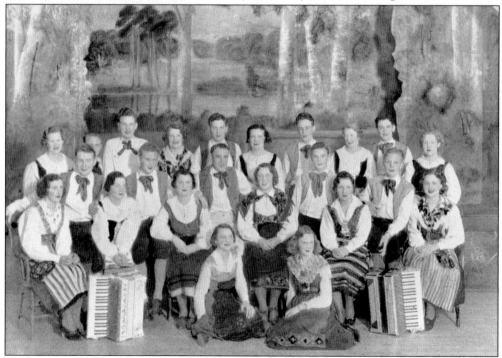

Many Swedish organizations sponsored dance groups, and North Star Lodge No. 2 was no exception. Their group, the Ring Dancers, was directed by Alma Haugland in the 1920s and 1930s. The stage backdrop was hand painted by North Star members. (Courtesy North Star Lodge No. 2.)

North Star Lodge No. 2 met at the IOGT (International Order of Good Templars) Hall, built in 1910 at 1109 Virginia Street in Seattle. Construction was financed by a building association; stock was issued at $5 per share, which paid six percent interest. Two storefronts on the first level were rented out, while three halls on the second floor were available for lodge use and for rental. The building was sold to Budget Rent-a-Car in 1981. (Courtesy North Star Lodge No. 2.)

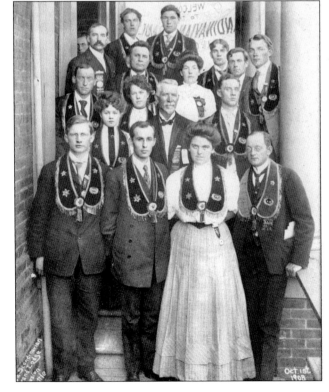

Members and officers of the Scandinavian Grand Lodge are pictured at a meeting in Seattle on October 1, 1908. The group includes members of Seattle's North Star Lodge No. 2. (Courtesy North Star Lodge No. 2.)

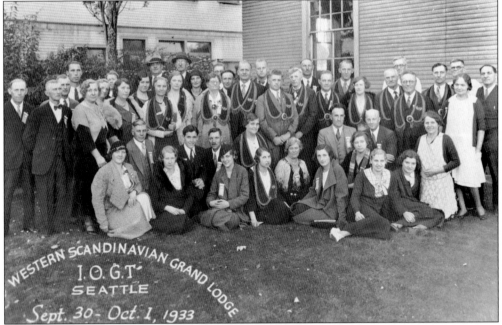

North Star Lodge No. 2 members and officers attended the 25th anniversary of the Western Scandinavian Grand Lodge, held in Seattle from September 30 to October 1, 1933. The photograph was taken outside the North Star Lodge No. 2 IOGT building at 1109 Virginia Street. (Courtesy North Star Lodge No. 2.)

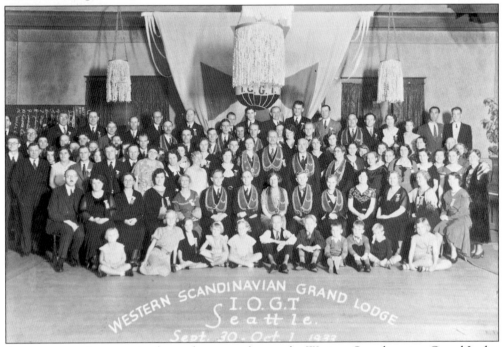

A commemorative portrait of attendees was taken at the Western Scandinavian Grand Lodge 25th anniversary celebration outside the IOGT building at 1109 Virginia Street. (Courtesy North Star Lodge No. 2.)

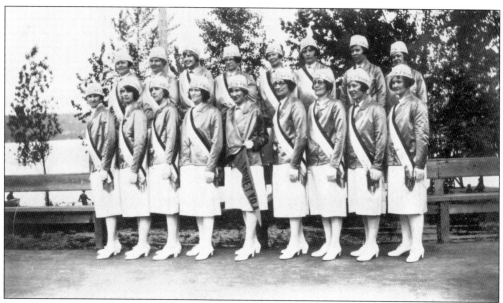

Vasa Park on Lake Sammamish was the setting for many activities in the Swedish American community. This photograph of a group of young women from the Vasa "Frihet" (Freedom) Lodge, which meets in Ballard, was taken in the 1930s. Edith Matilda (Lindquist) Hanson, who emigrated from Sweden in 1923, was among them. (Courtesy Carolee Jones.)

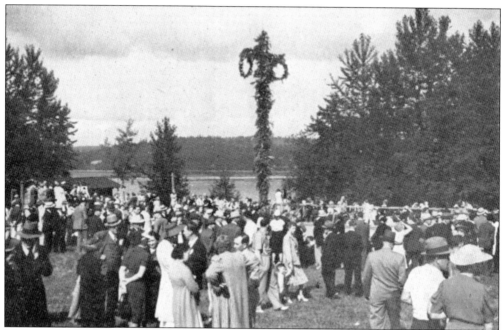

Midsummer celebrations in Seattle were organized by the Swedish Club until 1924, when the Order of Vasa took over the arrangements. From 1924 to 1928, the celebrations were held at Peoples Park in Renton Junction (now the site of the Southcenter shopping mall), and in 1929, Midsummer gatherings began being held at Vasa Park on Lake Sammamish. This Midsummer picture, with the traditional maypole, is from Vasa Park in the 1930s. (Courtesy author's collection.)

'Visit
VASA PARK
On Beautiful Lake Sammamish

PROGRAM

17th Annual Swedish

Midsummer Festival

VASA PARK
Lake Sammamish

☆

Saturday, Sunday, June 25-26
1938

Midsummer, the traditional Swedish solstice celebration, has been celebrated at Vasa Park for many years. (Courtesy Christy Wicklander.)

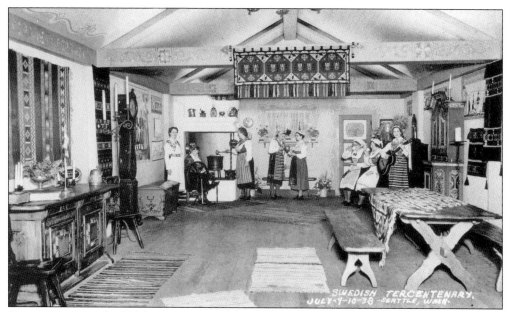

To commemorate the 300th anniversary of the New Sweden colony in the Delaware River valley, a Swedish *stuga* (cottage) was set up in a downtown storefront and furnished with traditional Swedish handicrafts and furniture. (Courtesy Nordic Heritage Museum.)

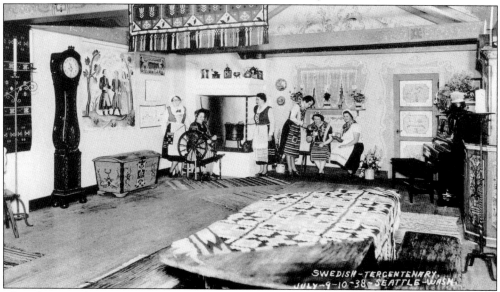

This photograph postcard shows another view of the Swedish cottage created for the Swedish Tercentennial in July 1938. Another event was a special pageant, *Nya Sverige* (New Sweden), composed by University of Washington music professor August Werner for the occasion. The pageant was staged at Civic Auditorium, with music performed by the Svea Male Chorus, the Norwegian Male Chorus, the Harmony Singing Society, the Norwegian Ladies Chorus of Seattle, the Swedish Ladies Auxiliary Chorus, and members of the Swedish Tabernacle Orchestra. The crucial role of Axel Oxenstierna, Swedish regent after the untimely death of Gustavus Adolphus in 1632, was played by *Svenska Journalen* (Swedish Journal) business manager and radio announcer Gus Backman. (Courtesy Nordic Heritage Museum.)

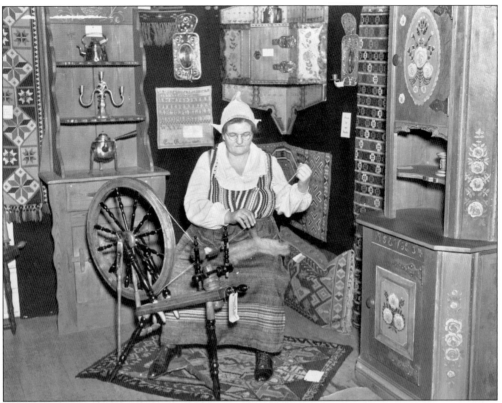

Ingeborg Söderlund demonstrated traditional spinning techniques at the Frederick and Nelson department store in 1937. (Courtesy *Seattle Post-Intelligencer* Collection, MOHAI.)

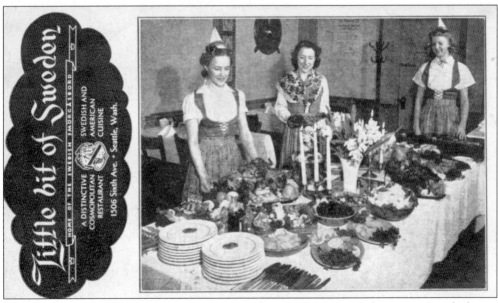

The Little Bit of Sweden restaurant, which operated on Sixth Avenue in downtown Seattle during the 1940s, featured an authentic Swedish *smörgåsbord*. (Courtesy Nordic Heritage Museum.)

Three

SWEDISH AMERICANS

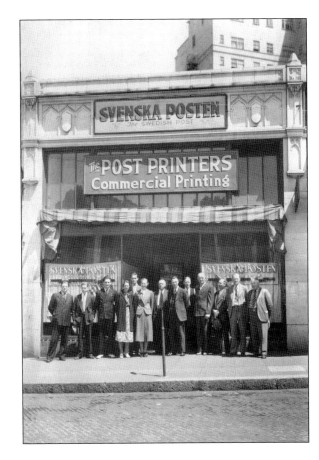

Employees of *Svenska Posten* (the *Swedish Post*), a Swedish-language newspaper, stand in front of the newspaper's offices on Eighth Avenue, not far from the Swedish Club, in July 1938. (Courtesy UW Special Collections, UW9091.)

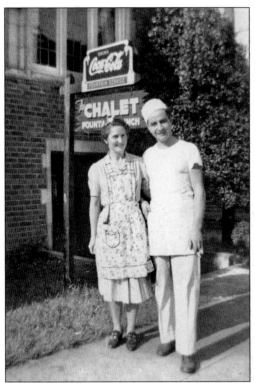

Siri and Matts Djos opened the Chalet restaurant in Eagleson Hall across from the University of Washington campus in September 1941. The restaurant served a Swedish *smörgåsbord* daily, with occasional dinner music provided by Siri (an accomplished violinist) and Beverly Sherman. (Courtesy Christy Wicklander.)

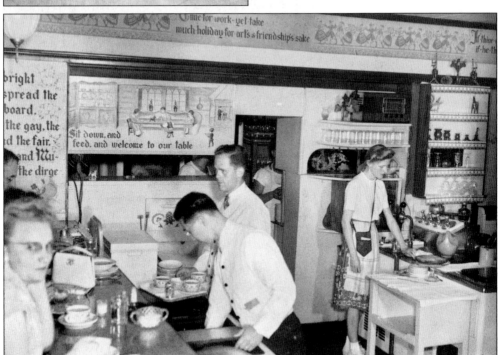

This is an inside view of the Chalet restaurant run by Matts and Siri (Engmann) Djos. Notice the beautiful wall paintings done in the traditional style of Matts's home province of Dalarna, Sweden. (Courtesy Christy Wicklander.)

Siri Engmann was an accomplished violinist with a professional career. After she married Matts Djos, she continued to perform occasionally, especially for events in the Scandinavian community. This publicity photograph is from 1930. (Courtesy Christy Wicklander.)

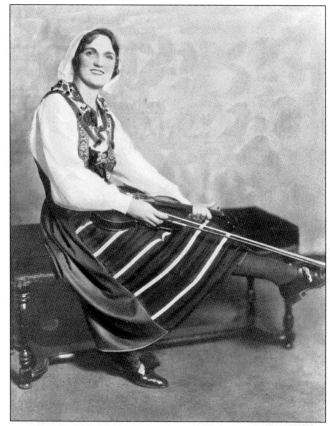

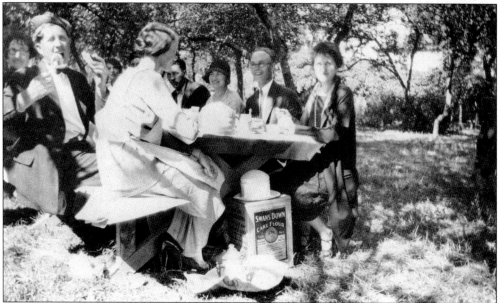

For more than 80 years, Vasa Park on Lake Sammamish has been the scene for many Swedish community events, such as the annual Midsummer celebration, as well as private parties and family picnics, like this one from the late 1920s. (Courtesy Carolyn Purser.)

Matts and Siri Djos operated this gallery, which featured Swedish imports, on University Way. The business later expanded to include two downtown locations. Their motto was "Good design costs no more." The small house was later razed for the construction of the professional building that now occupies the site. (Courtesy Christy Wicklander.)

A Bohemian Atmosphere based on a high standard
for discriminating people

"DALOM"

CULTURAL CENTER *and* SWEDISH DINING ROOM

Featuring

SMÖRGÅSBORD

1016 Boren Avenue **SEneca 0015**

Another venture started by Matts and Siri Djos was a "Cultural Center and Swedish Dining Room" called Dalom, located in "the handsome residence of the late Albert Hansen at the corner of Boren Avenue and Spring Street." Every enterprise undertaken by Matts and Siri Djos was marked by sophistication and good taste. Dalom also offered a Swedish *smörgåsbord*, and according to their brochure, "if you wish to indulge in this 'groaning board' of Nordic Delicacies the price is fifty cents per person." (Courtesy Christy Wicklander.)

Matts Djos (right) watches as a Swedish ceramics artist demonstrates a painting technique. Matts and his wife, Siri, often brought Swedish artists to their store on University Way. In 1950, the couple arranged an exhibition of Swedish arts and crafts at the Seattle Art Museum in Volunteer Park. (Courtesy Christy Wicklander.)

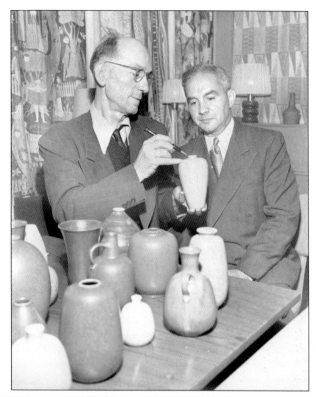

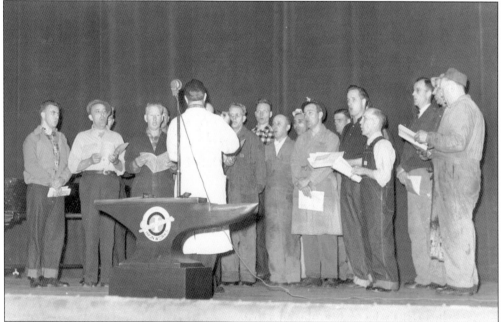

Employees at Isaacson Steel Works participated in a variety of recreational activities, including bowling teams, fishing derbies, and the company Glee Club, pictured here performing in the 1940s. The company was founded in 1907 by Swedish immigrant John Isaacson. (Courtesy Nordic Heritage Museum.)

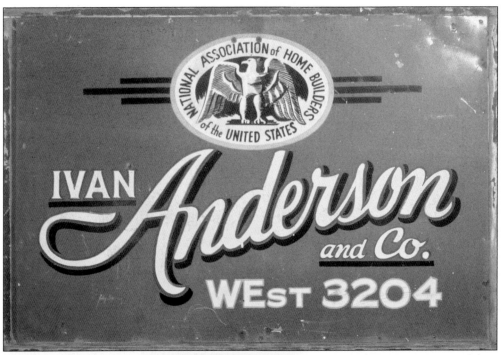

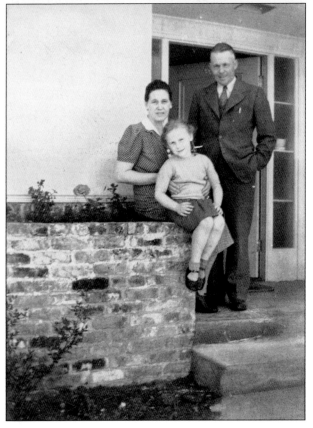

Ivan Anderson ran a successful construction business in West Seattle. Born in 1893, Ivan immigrated to America in 1913. He lived and worked as a cabinetmaker and carpenter in St. Paul, Pittsburgh, and Sacramento before settling in Seattle in 1927 with his wife, Esther, whom he married in 1918. Ivan was well known in the Swedish community as a generous, fair employer (who would hire Swedish carpenters, even if there wasn't quite enough work to go around) and for his enthusiasm for soccer. (Courtesy Gail Stevens.)

Contractor Ivan Anderson with wife Esther and daughter Lois are pictured in front of the house he built for his family in West Seattle. Many Swedish immigrants entered the construction and building trades. (Courtesy Gail Stevens.)

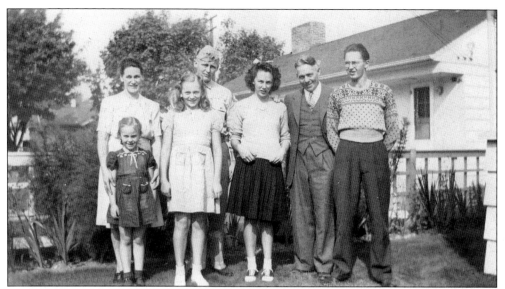

Ivan Anderson is shown with his wife, Esther (far left), and their five children in 1943. Their oldest son, Clarence (second row), disappeared over the Himalayas while serving as a pilot in the air force during the Second World War. (Courtesy Gail Stevens.)

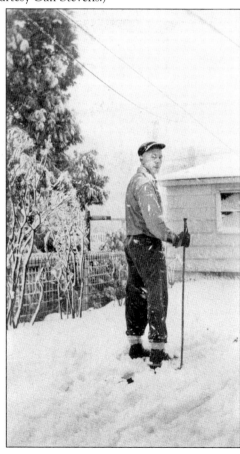

Swedes have a known fondness for cross-country skiing, as Ivan Anderson demonstrates in his West Seattle driveway on a snowy day in the 1940s. (Courtesy Gail Stevens.)

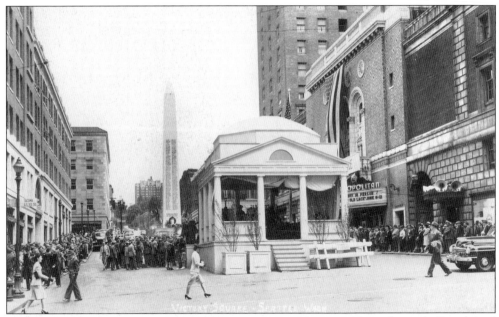

The pavilion known as "Victory Square" was set up on University Street between Fourth and Fifth Avenues in downtown Seattle in 1942 in support of the war effort. When this picture was taken, *Arsenic and Old Lace* was playing at the nearby Metropolitan Theater. (Courtesy Clinton White.)

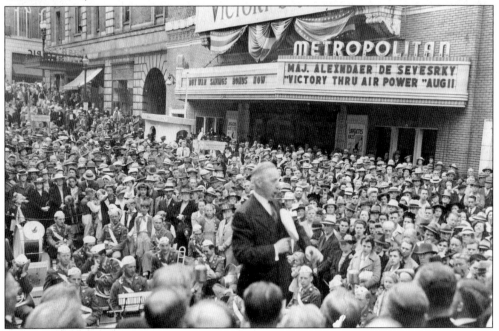

The Svea Male Chorus performs on Swedish Day at Victory Square in downtown Seattle in August 1942. In the first 78 days of Victory Square's existence, $2 million was raised. Among the large donors on Swedish Day mentioned in the press were Swedish Hospital, Dr. Nils Johansson, Isaacson Iron Works, and Henry Isaacson. In 1943, a reprise of Swedish Day broke that year's one-day bond-buying record. (Courtesy Nordic Heritage Museum.)

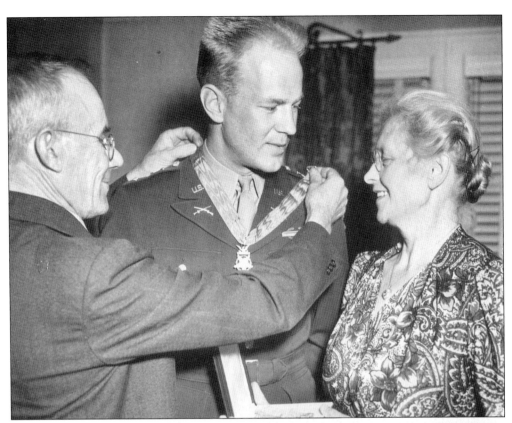

Many second-generation Swedish Americans served in the Armed Forces during the Second World War. First Lt. Arnold J. Bjorklund was awarded the Congressional Medal of Honor for exceptional bravery against German forces during the invasion of Italy at Salerno in September 1943. Seriously wounded during the battle, Bjorklund returned to the United States and received his medal from Pres. Franklin Delano Roosevelt at the White House. Here he is shown with his parents, Karl and Sofia Bjorklund, in their Crown Hill home. (Courtesy Don Ostrand.)

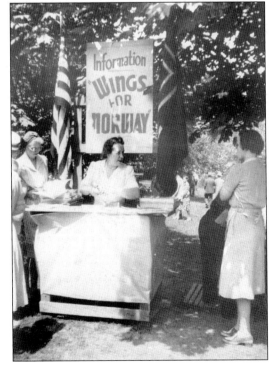

A picnic was held in Vasa Park in August 1942 to raise funds for the Wings for Norway project, a training program for Norwegian pilots in Canada, during the Second World War. As was often the case, Svea Male Chorus provided music for the occasion. (Courtesy Nordic Heritage Museum.)

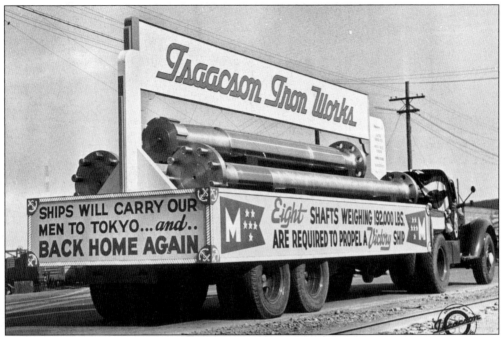

Isaacson Iron Works, founded by Swedish immigrant John Isaacson in 1907, was an important supplier of iron and steel products to the military during the Second World War. Isaacson, born in 1875, immigrated to America in 1891. The company continued to be a family-run enterprise for many years under the leadership of his son, Henry Isaacson Sr., and later his grandson, Henry Isaacson Jr. (Courtesy Nordic Heritage Museum.)

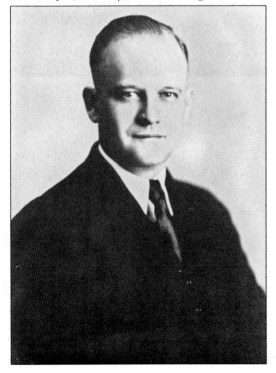

Philip Johnson served as president of Boeing from 1926 to 1933 and again from 1939 until his death in 1944. Johnson was born in Seattle in 1894, the son of Swedish immigrant parents, Charles and Hannah Johnson, and attended Seattle public schools. In the 1950s and 1960s, a new generation of Swedish immigrants (popularly known as "Boeing Swedes") would be drawn to Seattle by employment opportunities at Boeing, especially as engineers. The story of their contributions to the various Boeing aircraft programs would be worth a book in itself. (Courtesy Nordic Heritage Museum.)

The University of Washington Swedish Club celebrated its first Lucia pageant in 1948. That year's Lucia is shown with her attendants, including a bearded *tomte* (Swedish gnome), who was probably not a UW student. (Courtesy Brian B. Magnusson.)

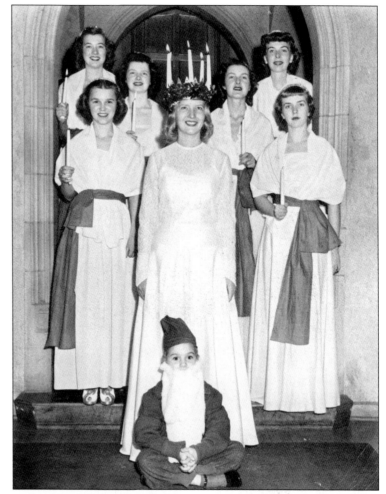

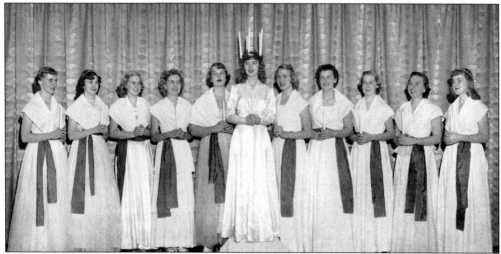

The Lucia pageant at the University of Washington became an annual tradition. Here Lucia is shown with her attendants *c.* 1954. (Courtesy Nordic Heritage Museum.)

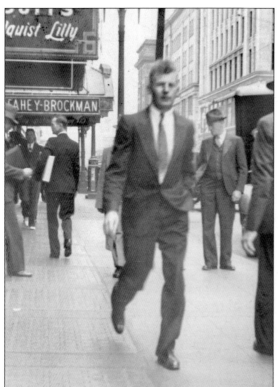

Ivar Bergquist, Swedish immigrant and Seattle businessman, is pictured in downtown Seattle in the late 1940s. This photograph was no doubt taken by a street photographer, a common practice at that time. (Courtesy Carolyn Purser.)

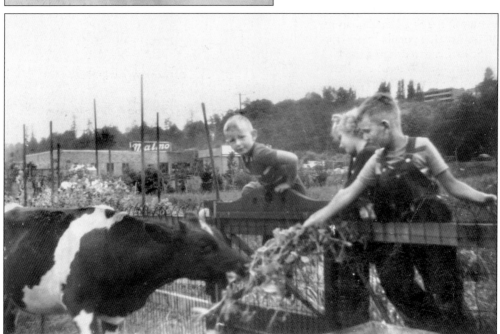

In the late 1940s, cows could still be seen grazing near the present location of University Village. Kees and Karl Ellerbrook were refugees from Holland who lived with their family in a small house on property owned by Ivar Bergquist. His granddaughter, Carolyn, stands between her two Dutch friends. Note the Malmo Nursery sign in the background. (Courtesy Carolyn Purser.)

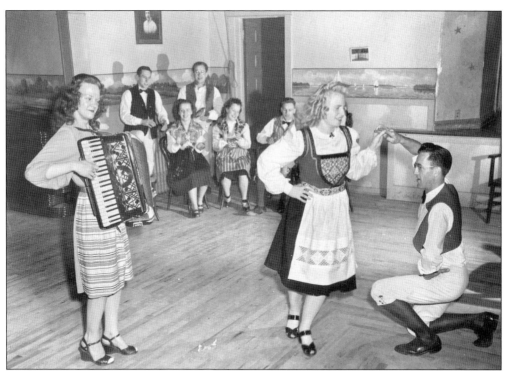

Scandinavian folk dancing with live accordion music was still a popular pastime at the Swedish Club in the 1940s. Another popular destination for Scandinavian dancing (such as *schottisch* and *hambo*) was Bert Lindgren's dance hall in Kenmore. (Courtesy *Seattle Post-Intelligencer* Collection, MOHAI.)

SONGS
for Community Singing

Assembled by
CECILIA GRANBERG AND MINNIE NORENSTRAND

Published by
HENNING E. ANDERSON

Singing makes a way to the inner man and makes you feel friendly too.

"Let's All Sing"

This songbook, printed in Seattle probably in the 1940s, contained the lyrics for songs in Swedish, the Norwegian and Swedish national anthems, and American popular and patriotic songs. The inside cover, an advertisement for Johnson and Sons Mortuary, states that "We recommend singing when your spirits are low." (Courtesy Clinton White.)

In 1944, Seattle writer and entertainer John Nordeen, manager of the Swedish Club for many years, decided it was time to write a history of the Swedish Club. The cover shows a drawing of the old club building at Eighth Avenue and Olive Way. Nordeen wrote the book in Swedish; the last chapter, however, is in English, a nod to a newer generation less fluent in the language of the old country. (Courtesy Clinton White.)

Writer and entertainer John Nordeen loved to perform under the stage name "Skrällbom." Traveling Swedish American vaudeville troupes made regular tours to American cities with large Swedish populations, including Seattle and Tacoma in the first decades of the 1900s. Nordeen belonged to this tradition, as does beloved Seattle performer Stan Boreson, who still performs in 2007. (Courtesy Swedish Cultural Center.)

The cover of *Här och Där* (*Here and There*) by Augusta Hägerman, published in Seattle in 1945, illustrates the Swedish immigrant's memories of home in Sweden with impressions of a new life in the city of Seattle, represented by the Smith Tower, which would later be owned for a time by Swedish American businessman Ivar Haglund. (Courtesy Swedish Cultural Center.)

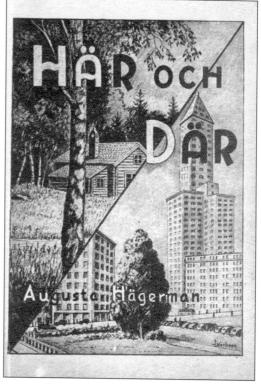

An annual event that always drew a large crowd was the Swedish Picnic, held first at Silver Lake and later at Vasa Park. Note from the sign in the background that there was enough interest in 1945 in news from Scandinavia and the Scandinavian community to justify a special column in the *Seattle Post-Intelligencer*. (Courtesy *Seattle Post-Intelligencer* Collection, MOHAI.)

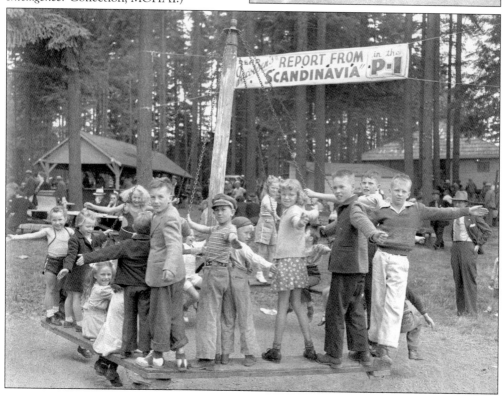

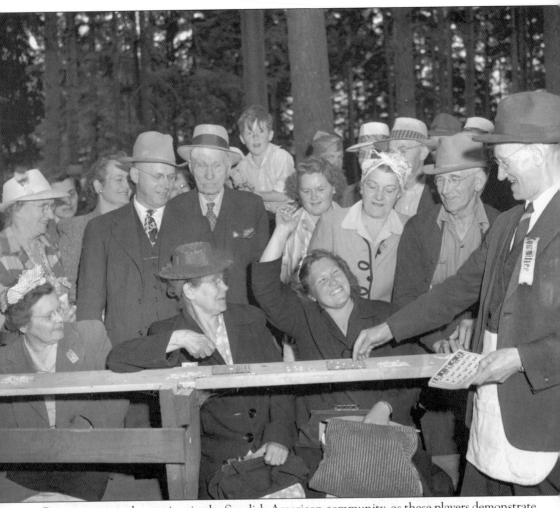

Bingo was a popular pastime in the Swedish American community, as these players demonstrate at the Swedish Picnic in 1945. (Courtesy *Seattle Post-Intelligencer* Collection, MOHAI.)

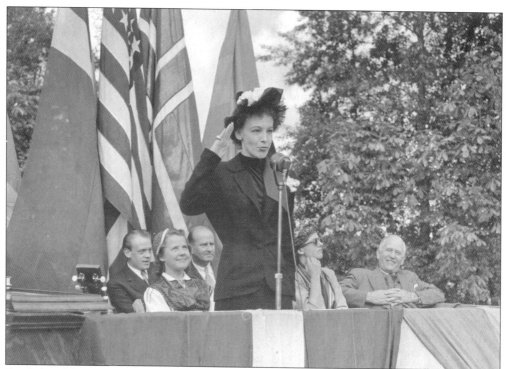

Swedish celebrities sometimes visited the Seattle area, drawn by the large Swedish community here. Swedish film star Signe Hasso was the guest of honor at the Swedish Picnic in 1947 held at Vasa Park on Lake Sammamish. (Courtesy *Seattle Post-Intelligencer* Collection, MOHAI.)

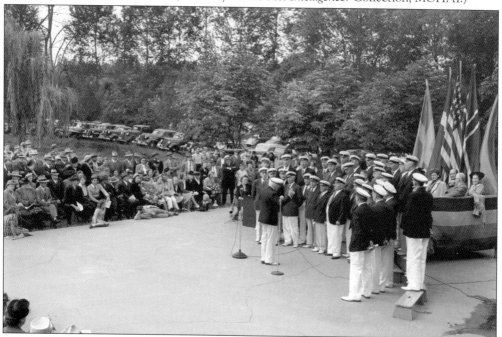

A performance by the Svea Male Chorus was also part of the entertainment program at the 1947 Swedish Picnic. (Courtesy *Seattle Post-Intelligencer* Collection, MOHAI.)

Bob Hultgren brought his accordion to the Swedish Picnic in 1949. (Courtesy *Seattle Post-Intelligencer* Collection, MOHAI.)

Coffee is a must at almost any Swedish social occasion, and these men at the 1951 Swedish Picnic are making sure there is enough to go around. (Courtesy *Seattle Post-Intelligencer* Collection, MOHAI.)

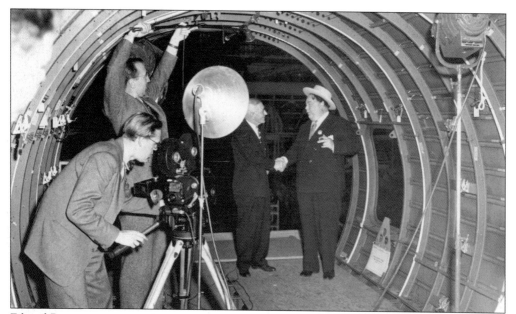

Edvard Persson was a popular comedian and singer in Sweden from the 1920s to the 1950s. He made a well-publicized American tour in 1946, beginning with a performance in Carnegie Hall and followed by visits to the Swedish American communities in Chicago, Minneapolis, and Seattle. While on tour, Persson filmed a comedy, *Jens Månsson i Amerika*, making use of Boeing's Plant 2 in Seattle as a film location. Here journalist Gus Backman shows Persson the inside of a Boeing aircraft under construction. (Courtesy Nordic Heritage Museum.)

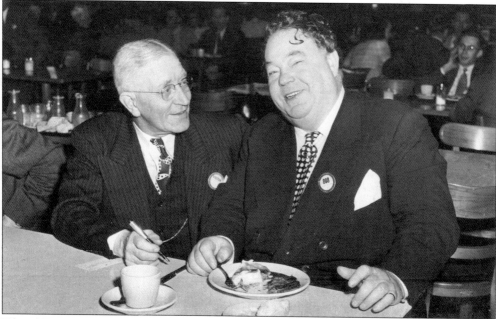

Edvard Persson seems to be enjoying his visit to Seattle as journalist Gus Backman takes notes for his weekly radio program. John Nordeen's informative chronicle, *Svenska Klubbens historia* (*The History of the Swedish Club*), notes that a Persson film, *Flickorna från gamla stan* (*The Girls from Old Town*), was shown in Seattle in 1935. (Courtesy Nordic Heritage Museum.)

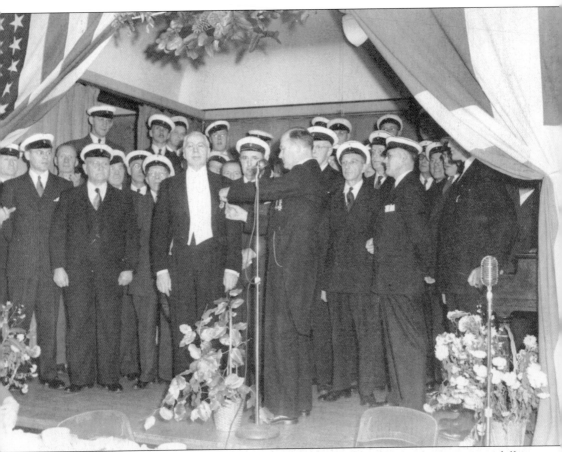

Members of the Svea Male Chorus watch as their director, C. H. Sutherland, receives a medallion from the Swedish consul, Ivar Lundequist, on behalf of Swedish king Gustav V in 1948. (Courtesy Nordic Heritage Museum.)

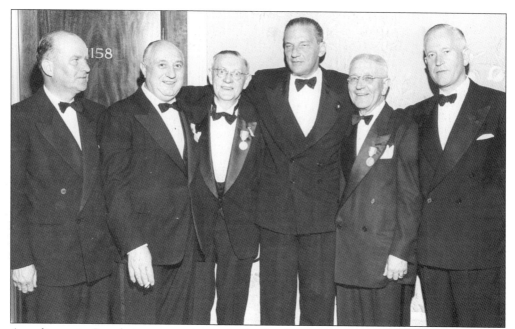

At a dinner in Seattle in connection with the Swedish Pioneer Centennial in 1948, Swedish consul Ivar Lundequist (left) presented Pioneer Medals from the Swedish government to, from left to right, Einar Carlson, A. N. Rumin, and Gus Backman. Swedish ambassador Erik Boheman is in the center. (Courtesy Nordic Heritage Museum.)

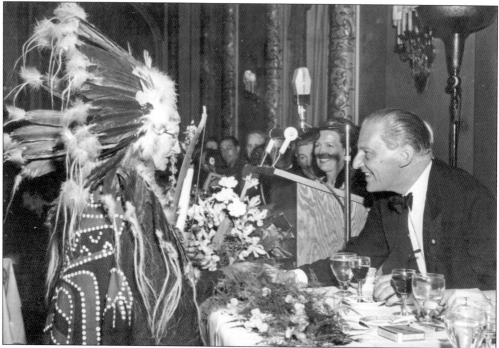

Early settler K. O. Erickson of Port Angeles was on friendly terms with Native Americans and was given the name White Bear. Here he converses with Swedish ambassador Erik Boheman in 1948 at the Swedish Pioneer Centennial banquet. (Courtesy Nordic Heritage Museum.)

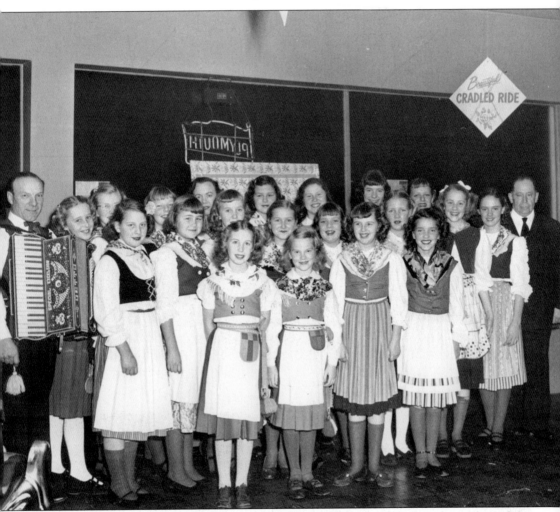

Swedish-speaking immigrants from Finland (called Swede Finns) and their descendants form a special group within the larger Swedish community. The Order of Runeberg, a Swede Finn lodge, organized many activities, including this dance group shown on tour in Salt Lake City in 1950. Flanking the dancers are accordion player Edwin Staaf (left) and director August Lillquist (right). (Courtesy Swedish Finn Historical Society.)

The Order of Runeberg also sponsored the Little Theater Group. Ready to take the stage in 1952 are, from left to right, Elizabeth Berg, Elvin Purrington, Ruth Bergquist, Runar Alskog, George Halvor, and Marlene Jules. (Courtesy Swedish Finn Historical Society.)

Men's Night at the Order of Runeberg was always fun, though the men didn't dress like this for every meeting. The theme for this party in 1948 was "Back to School." (Courtesy Swedish Finn Historical Society.)

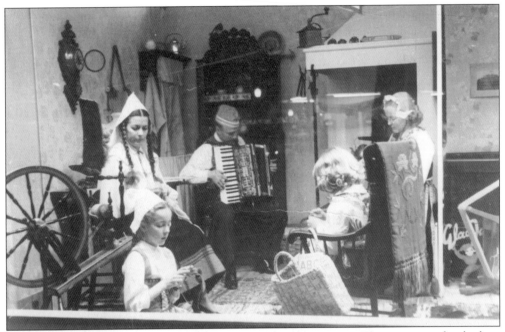

The Ballard Chamber of Commerce held an annual competition at Christmastime for the best store window display. The Ballard Furniture Store won in 1949 for a display showing the interior of a traditional home in Österbotten, a Swedish-speaking region of Finland. (Courtesy Swedish Finn Historical Society.)

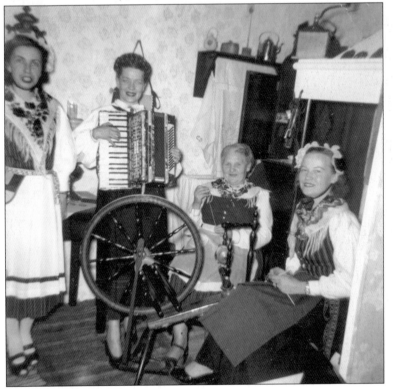

Gathered around the spinning wheel in the prize-winning display window are, from left to right, Wilma Sellin, Ruth Fish, Mrs. Frank Sandstrom, and Evelyn Staaf. (Courtesy Swedish Finn Historical Society.)

Engstrom's Home Bakery was a neighborhood landmark from the 1940s through the 1960s. Here the Engstrom kids, Judy and Bill, pose in front of the family business in 1945. (Courtesy Bill Engstrom.)

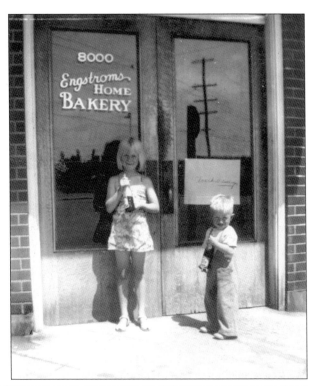

William Engstrom stands in front of his Ballard bakery c. 1950. (Courtesy Bill Engstrom.)

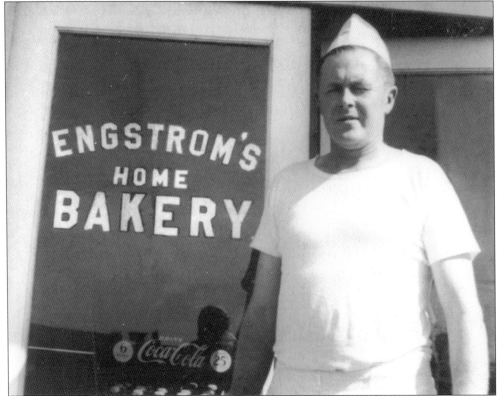

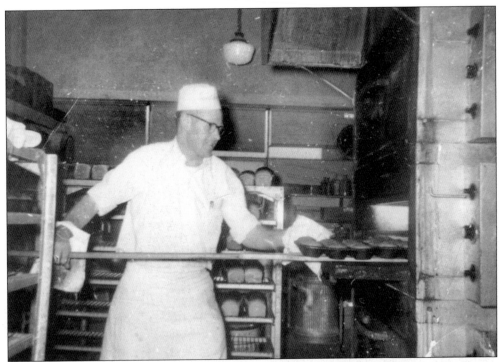

Running a bakery is hard work. Here William Engstrom takes bread from the oven at Engstrom's Home Bakery in 1956. (Courtesy Bill Engstrom.)

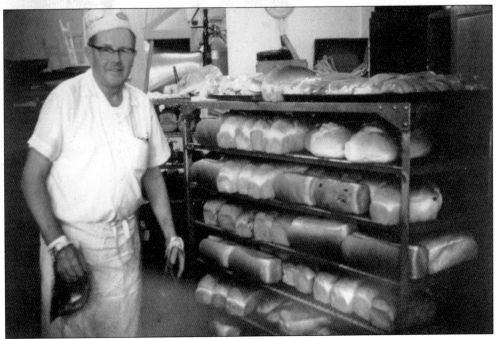

The results of a morning's hard labor, William Engstrom takes a break next to finished loaves of bread. (Courtesy Bill Engstrom.)

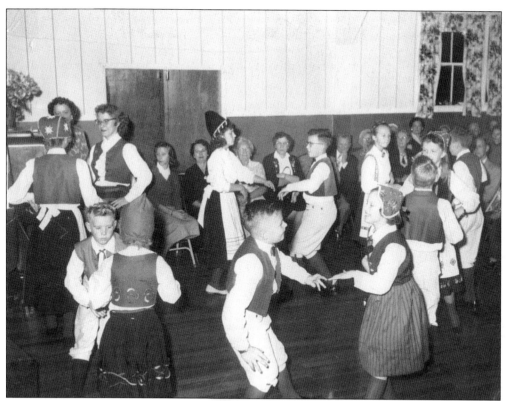

The Swedish Club organized folk dance groups for children of various ages. Here the group performs at the Fall City lodge of the Order of Vasa in the fall of 1959. Alana (Johnson) Granstrom, then in her early teens, is in the middle with the dark hat. (Courtesy Alana Granstrom.)

Harry Fabbe, shown in hiking boots and bow tie, was the longtime editor of *Svenska Posten* (the *Swedish Post*). This Swedish-language newspaper was published in Seattle from 1936 until 1976. (Courtesy author's collection.)

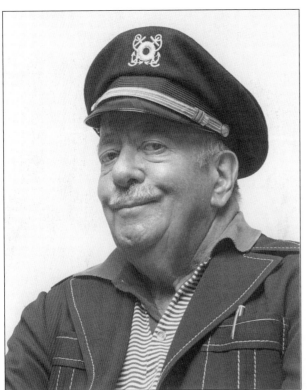

Ivar Haglund, restaurateur, port commissioner, and entertainer, was a major force in Seattle. (Courtesy Nordic Heritage Museum.)

This candid shot from the 1950s, taken on board a Seattle ferry, shows, from left to right, Ivar Haglund (with guitar), Jim Stevens, Betty MacDonald (best-selling author of *The Egg and I*), and Arlene Francis. Ivar, always ready to perform, may have treated the ferry passengers to a free concert. (Courtesy Nordic Heritage Museum.)

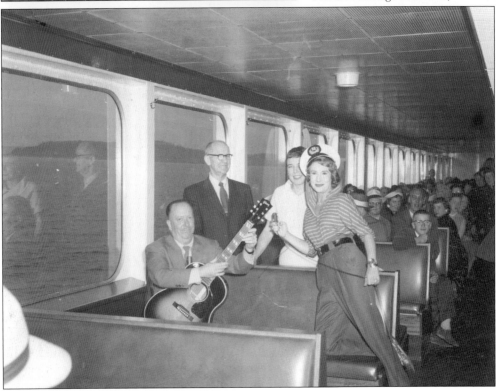

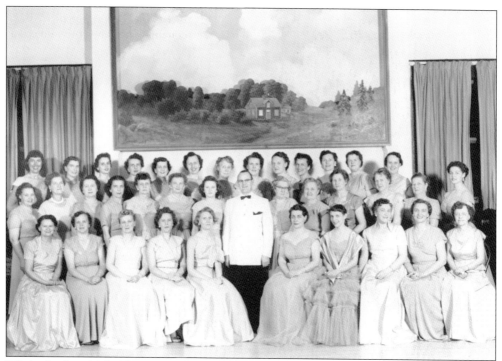

While the Svea Male Chorus was formed in 1905, a corresponding group, the Swedish Women's Chorus, did not come into existence until 1951. Here they are shown in their first group portrait, taken at the Swedish Club, with director Carl Zeed. (Courtesy Lilly Moen.)

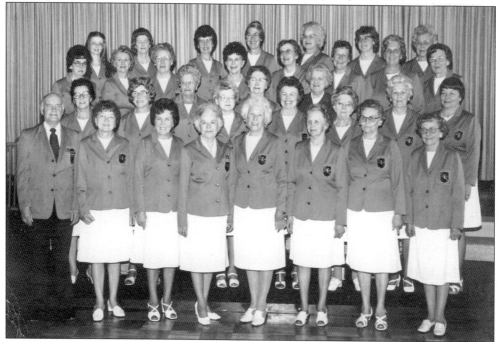

Swedish Women's Chorus is shown in a group portrait, taken in 1980, with director George Halvor. The chorus is still active today. (Courtesy Lilly Moen.)

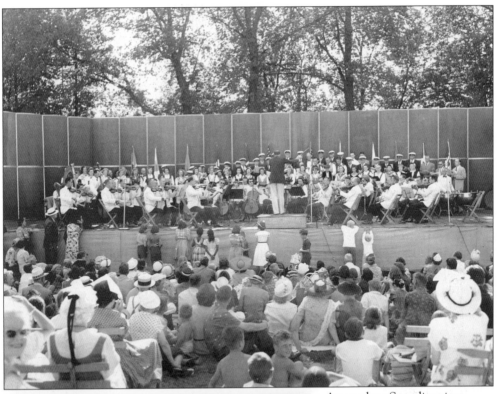

An outdoor Scandinavian Music Festival, featuring choruses and instrumental music, was held annually for a number of years at either Seward Park or Volunteer Park. This performance was in Volunteer Park. (Courtesy Swedish Finn Historical Society.)

Pianist and director John Sundsten led a number of Scandinavian music groups in Seattle and was an organizer of the Scandinavian Music Festival. (Courtesy Swedish Finn Historical Society.)

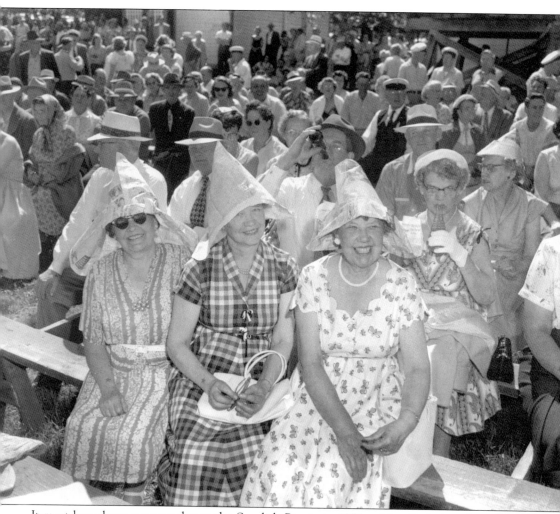

It must have been a sunny day at the Swedish Picnic in 1955 at Vasa Park, but these ladies improvised with newspaper hats. (Courtesy *Seattle Post-Intelligencer* Collection, MOHAI.)

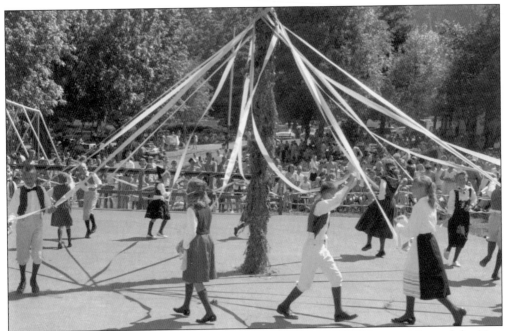

An important Midsummer tradition is the raising of the maypole. Here members of the Vasa lodge's children's dance group Snödroppen perform at Vasa Park in 1955. (Courtesy *Seattle Post-Intelligencer* Collection, MOHAI.)

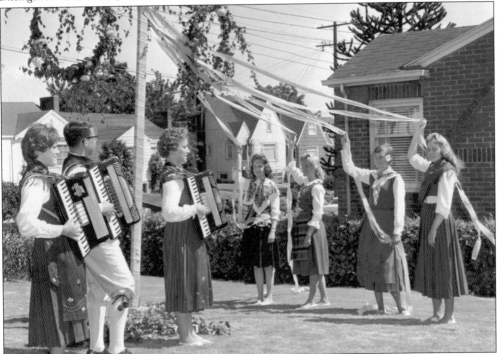

Midsummer can also be celebrated at home, with a maypole improvised in the front yard. This photograph of a group of youthful musicians and dancers from 1960 was probably taken somewhere in north Seattle. (Courtesy *Seattle Post-Intelligencer* Collection, MOHAI.)

The Swedish Club is seen as it appeared in the 1950s, shortly before the move to Dexter Avenue North in 1961. (Courtesy author's collection.)

When the new Swedish Club building opened on Dexter Avenue North, it seemed like a long way from the old downtown location. (Courtesy *Seattle Post-Intelligencer* Collection, MOHAI.)

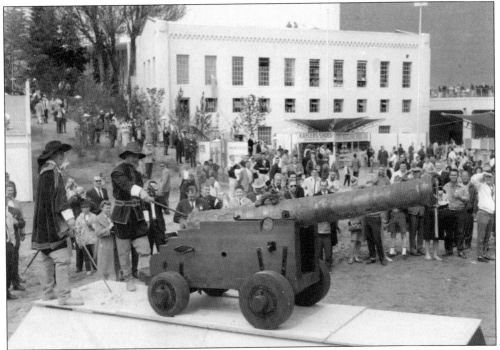

To help enliven the opening day of the 1962 World's Fair in Seattle, Sweden sent cannon from the warship *Vasa*. The *Vasa*, which sank on its maiden voyage in 1628, is now on display in its own museum and a major tourist attraction in Stockholm. (Courtesy *Seattle Post-Intelligencer* Collection, MOHAI.)

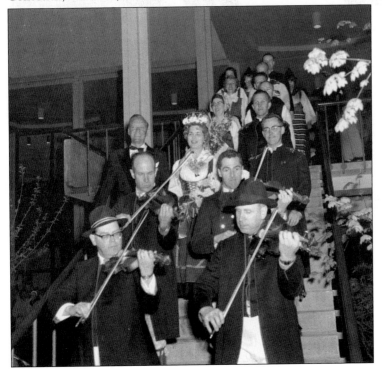

Several Swedish fiddlers came to Seattle for Swedish Week at the 1962 World's Fair. The invitation probably came from Gordon Ekvall Tracie, founder of Skandia Folkdance Society, who made several trips to Scandinavia to collect folk tunes and meet traditional performers. (Courtesy *Seattle Post-Intelligencer* Collection, MOHAI.)

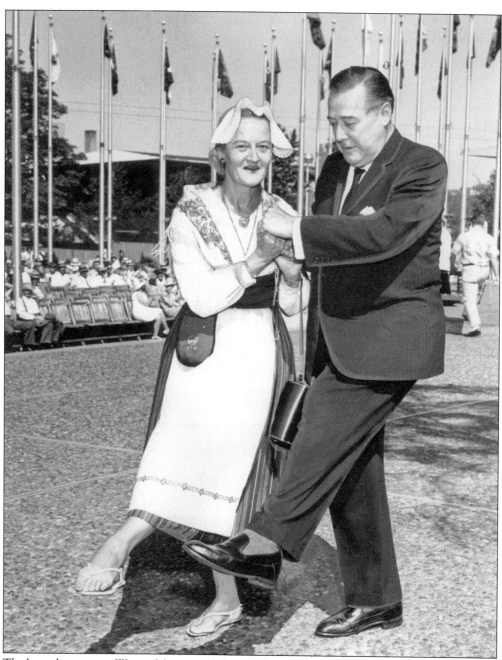

The legendary senator Warren Magnuson (whose address in the Swedish Club membership directory was listed as "U.S. Senate Building, Washington, D.C.") practices a folkdance step at the Nordic Festival held at the Seattle Center in 1966. (Courtesy Ron DeRosa/the *Seattle Times.*)

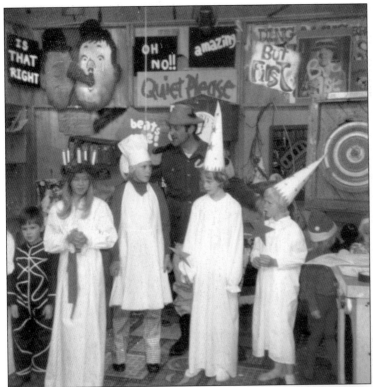

Many recent immigrants maintain ties to Sweden through local organizations such as the Swedish Cultural Society (*Kulturförbundet*). In 1975, children from the Swedish Cultural Society appeared on the J. P. Patches program to demonstrate a Lucia procession. Lucia wears a crown of candles; the pointed hats are worn by "star boys." Although J. P. himself can't be seen in this photograph, his sidekick Gertrude is in the background. (Courtesy Astor and Solveig Rask.)

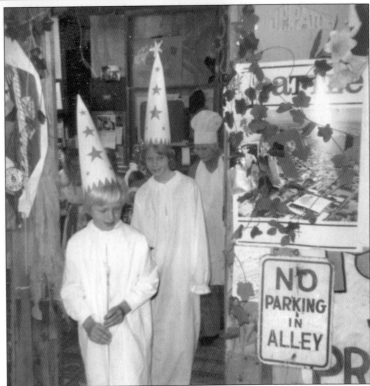

These "star boys" from the Swedish Cultural Society seem to be having fun exploring the set of the J. P. Patches Show. (Courtesy Astor and Solveig Rask.)

Many Swedish traditions are family oriented. Here members of the Rask family, including Astor Rask (right) and daughter Tina (left), are out to catch crayfish, a traditional Swedish, late-summer delicacy, in Green Lake. (Courtesy Astor and Solveig Rask.)

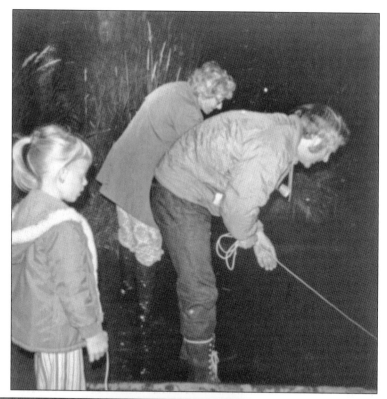

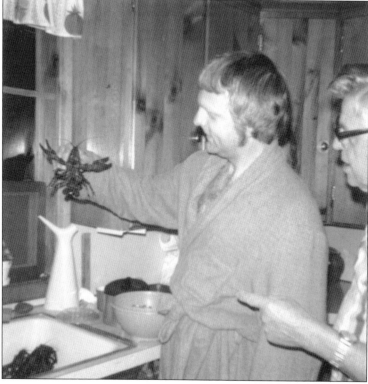

After a successful crayfish expedition, an especially fine specimen is inspected by Astor Rask and his father-in-law. (Courtesy Astor and Solveig Rask.)

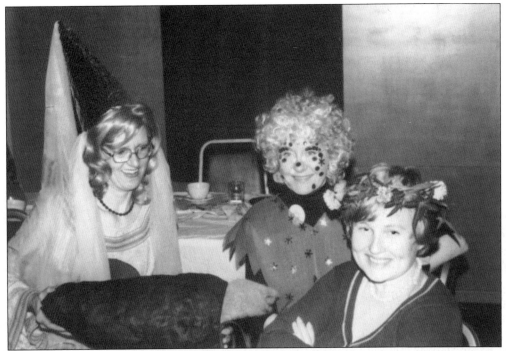

The Swedish Cultural Society (*Kulturförbundet*) was established in 1921, and continues to promote Swedish culture and traditions in the Seattle area. Among the Swedish traditions that have been enjoyed by the group are masquerade balls in February. (Courtesy Astor and Solveig Rask.)

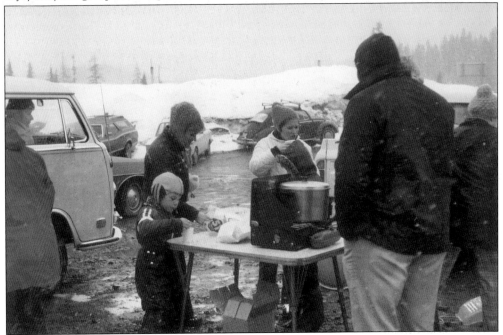

An afternoon of Swedish-style skiing at Snoqualmie Pass is even better with *blåbärssoppa* (blueberry soup) like they serve at Vasaloppet, the annual ski race in Sweden. (Courtesy Astor and Solveig Rask.)

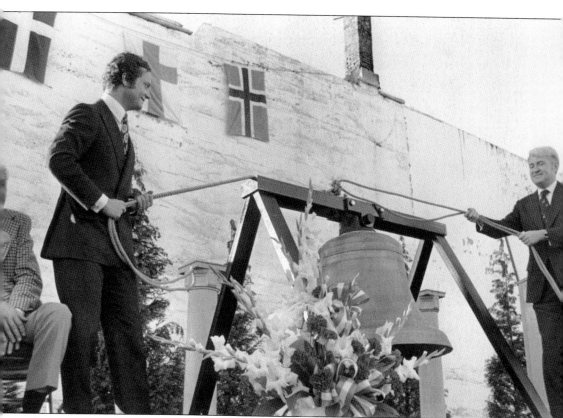

The king of Sweden, Carl XVI Gustaf, visited Seattle for three days in April 1976, becoming the first Swedish monarch to visit the city. The young king, who at the time was days away from turning 30, became king after the death of his grandfather Gustaf VI Adolf in 1973. While in Seattle, his main public appearance was in Ballard at Bergen Park, where he and Mayor Wes Uhlman rang the old Ballard city bell. (Courtesy *Seattle Post-Intelligencer* Collection, MOHAI.)

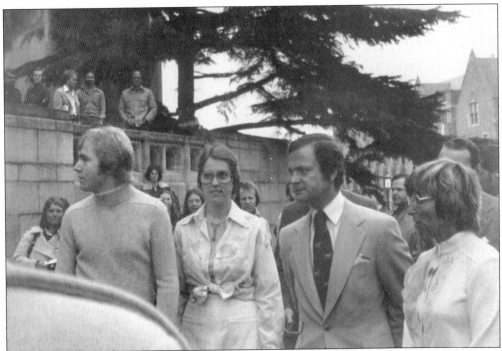

King Carl XVI Gustaf visited the University of Washington campus during his 1976 visit. Here he is flanked by Prof. Birgitta Steene (right) and then-student Kathie (Tollfeldt) Apolito. The king was pleased that students at UW took such an active interest in learning the Swedish language. (Courtesy Anne Tollfeldt.)

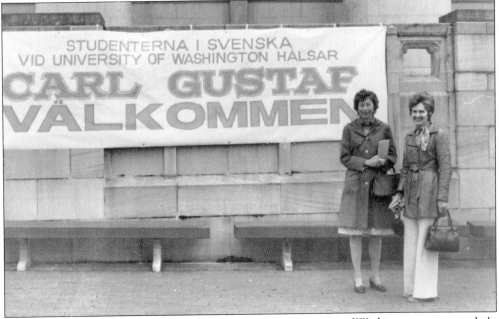

Good friends Jo Ingersoll and Anne Tollfeldt visited the University of Washington campus to help make King Carl XVI Gustaf feel *välkommen* in Seattle in 1976. The banner reads, "Students in Swedish at the University of Washington Welcome Carl Gustaf." (Courtesy Anne Tollfeldt.)

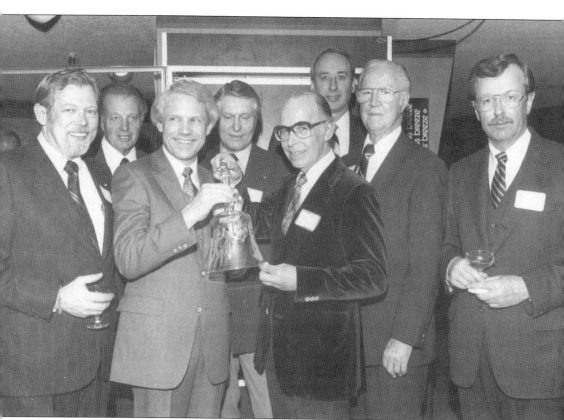

At a reception held at the Space Needle, the Orrefors company of Sweden presented a specially designed glass bell to commemorate the opening of the Nordic Heritage Museum in 1980. Founding of the museum represented a long-cherished dream to celebrate the heritage of the Seattle area's many immigrants from all five Nordic countries. Receiving the bell (now on display at the museum) are, from left to right, Thomas Stang (consul of Norway), Clifford Benson (consul of Sweden), Svein Gilje (first president of the Nordic Heritage Museum), Bertil Lundh (a later president of the museum), Swedish designer Olle Alberius, Hartley Kniger (consul of Denmark), Carl Helgren (consul of Finland), and Jon Marvin Jonsson (consul of Iceland). (Courtesy Nordic Heritage Museum.)

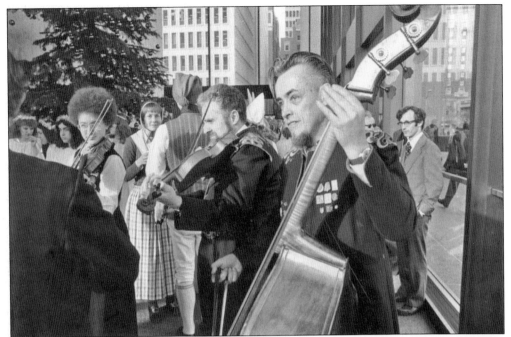

Gordon Tracie (bass) and Art Nation (fiddle) perform with other Seattle musicians at the 1979 Lucia celebration held in the lobby of the Bank of California building in downtown Seattle. Gordon Ekvall Tracie and Dick Sacksteder founded the Skandia Folkdance Society on the University of Washington campus in 1949. A catalyst for the local folk-music scene for many years, Skandia members continue to promote participation in Scandinavian music and dance. (Courtesy Nordic Heritage Museum.)

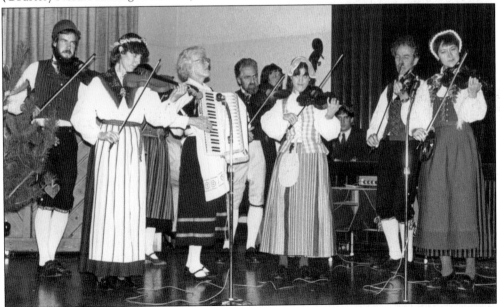

Interest in Scandinavian folk music and dance continues to be strong in the Seattle area. Speldosan performs at the University of Washington Swedish Club Lucia celebration at the Nordic Heritage Museum in 1980. (Courtesy Nordic Heritage Museum.)

An altar painting by Swedish American painter Jonas Olof Grafström (1855–1933) hung above the altar at Gethsemane Lutheran Church from 1915 until a new church was built in 1954. At that time, the painting was put into storage and basically forgotten. In 1993, the church custodian discovered the painting and alerted church member Jay Wallain. Wallain brought it to the attention of Brian B. Magnusson, a scholar of Nordic-American art who immediately identified the painting as one of more than 200 such devotional works by Grafström. The painting was subsequently restored through a donation by the family of Helen Bloomberg. An excellent example of Swedish American liturgical art, today the Grafström canvas can be viewed in a small chapel at Gethsemane Lutheran Church. (Courtesy author's collection.)

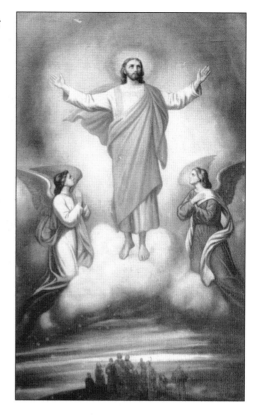

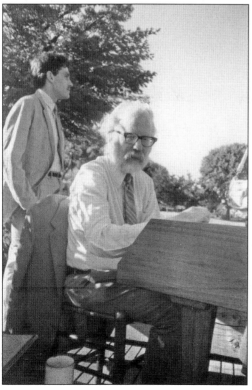

For many years Charles Wassberg has been active as a musician and teacher in the Seattle area, performing on organ, piano, or—as pictured—harpsichord in churches and other venues. For more than 25 years, Wassberg has served as organist for the traditional Christmas morning *julotta* service held at Gethsemane Lutheran Church. (Courtesy author's collection.)

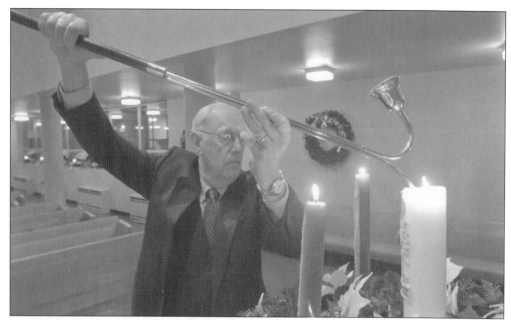

A traditional, early-morning Christmas service (*julotta* in Swedish) has been held at Gethsemane Lutheran Church every year since 1885. Church member Jay Wallain lights the candles before the service begins on December 25, 2002. (Courtesy *Seattle Post-Intelligencer*; photograph by Phil H. Webber; originally published December 26, 2002.)

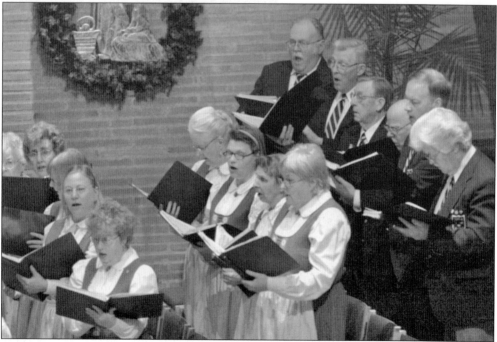

The entire *julotta* service at Gethsemane, including liturgy and sermon, is conducted in Swedish. Members of the Swedish Women's Chorus and Svea Male Chorus sing in the choir at the annual service in 2002. (Courtesy *Seattle Post-Intelligencer*; photograph by Phil H. Webber; originally published December 26, 2002.)

The Reverend Leslie Larson officiated at the Gethsemane *julotta* service from 1965 until his death in 2005. This Christmas morning tradition, held every year since the city's first Swedish Lutheran congregation was founded in 1885, provides an ongoing link between the first Swedish immigrants in Seattle and their descendants today. (Courtesy *Seattle Post-Intelligencer*; photograph by Phil H. Webber; originally published December 26, 2002.)

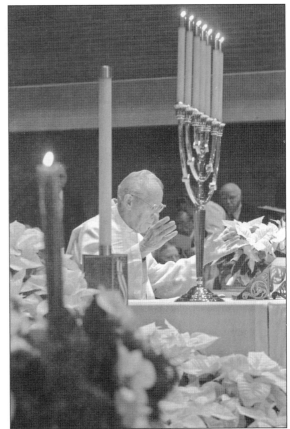

Jane Isakson Lea, active in the local Swedish community and Skandia Folkdance Society for many years, attended the 2002 *julotta* service with her husband, Jim Lea. (Courtesy *Seattle Post-Intelligencer*; photograph by Phil H. Webber; originally published December 26, 2002.)

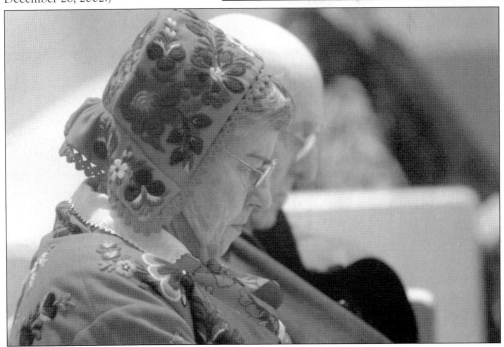

ACROSS AMERICA, PEOPLE ARE DISCOVERING SOMETHING WONDERFUL. *THEIR HERITAGE.*

Arcadia Publishing is the leading local history publisher in the United States. With more than 3,000 titles in print and hundreds of new titles released every year, Arcadia has extensive specialized experience chronicling the history of communities and celebrating America's hidden stories, bringing to life the people, places, and events from the past. To discover the history of other communities across the nation, please visit:

www.arcadiapublishing.com

Customized search tools allow you to find regional history books about the town where you grew up, the cities where your friends and family live, the town where your parents met, or even that retirement spot you've been dreaming about.

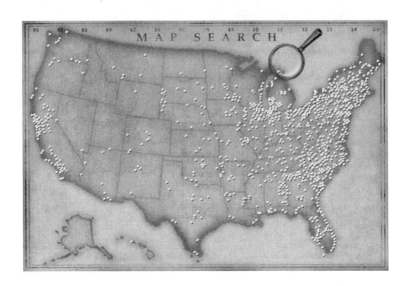